Prestel Museum Guide

Berggruen Museum
Berlin

Edited by
Hans Jürgen Papies

Prestel

Munich · Berlin · London · New York

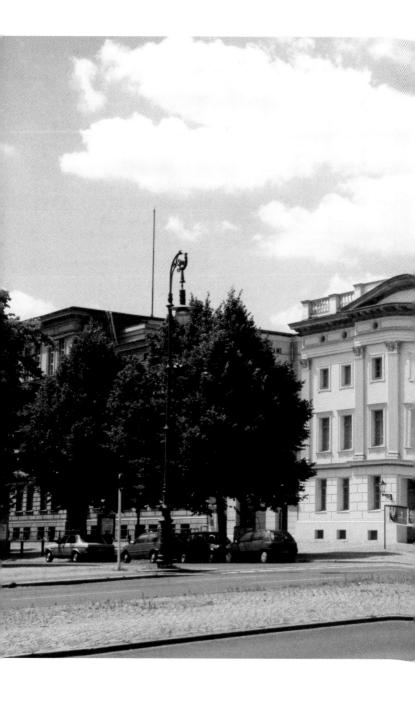

Façade of the Western Stüler Building, with the entrance to the Berggruen Museum, 1995

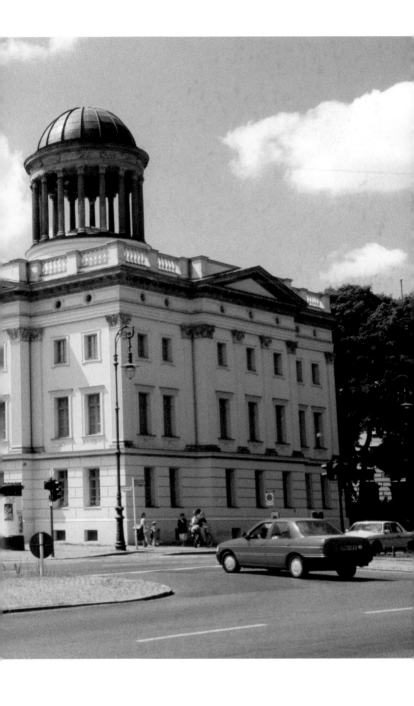

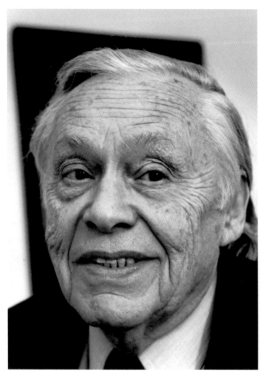

Heinz Berggruen, 1997

About Heinz Berggruen

'It is not without sadness that I say goodbye to my collection. It is, and will remain, my life's work. Parting is sorrow, as they say. To quote Virgil: *Sunt lacrimæ rerum* – all things have their tears. And that's how it is. But I'm also proud and optimistic, because my collection will now become a fixed part of the Berlin cultural landscape. I would not have been able to tread the very satisfying path of my latter-day "Berlin years" without the encouragement and collaboration of others. I am indeed grateful to them all, even if I mention here only my wife, Bettina.

Picasso, Matisse and Klee were stars of 20th-century art. Now they're anchored in Berlin for good. And I'm very happy about that.'

Heinz Berggruen on the occasion of the handover of his collection to the Stiftung Preussicher Kulturbesitz, 21 December 2000.

Heinz Berggruen was born in Berlin in 1914, but left his native country in 1936 to spend the larger part of his life in the United States and in Paris, where he was active for several decades as a successful art dealer. From the outset, the focus of his collection was on early modern art. Among the artists to whom he has devoted exhibitions are Klee, Kurt Schwitters, Matisse and, most frequently, Picasso. His collection was first exhibited in 1988, at the Kunstmuseum in Geneva and subsequently at the National Gallery in London for five years.

In 1997 Heinz Berggruen was decorated with the Grosses Verdienstkreuz des Verdienstordens (Grand Order of Merit – Germany's highest civilian decoration) and awarded an honorary chair by the Senate of Berlin. Since 1998 he has been an honorary member of the Bavarian Academy of Fine Arts. In 1999 he was awarded the national prize of the Deutsche Nationalstiftung. In 2000 he was raised to the rank of commander of the French Légion d'honneur, having previously been admitted to the Légion in 1971 in recognition of his services to modern art. Also in 2000 the Hochschule der Künste in Berlin conferred an honorary doctorate on him. In 2004, he was awarded the Order of the Federal Republic with star and epaulette and the freedom of the City of Berlin.

As an author, Berggruen's publications include his memoirs *Highways and Byways* (*Hauptweg und Nebenwege*), *Abendstunden in Demokratie*, *Ein Berliner kehrt heim*, *Monsieur Picasso und Herr Schaften* and *Spielverderber, nicht alle*. He is a regular contributor to the German newspaper *Frankfurter Allgemeine Zeitung*.

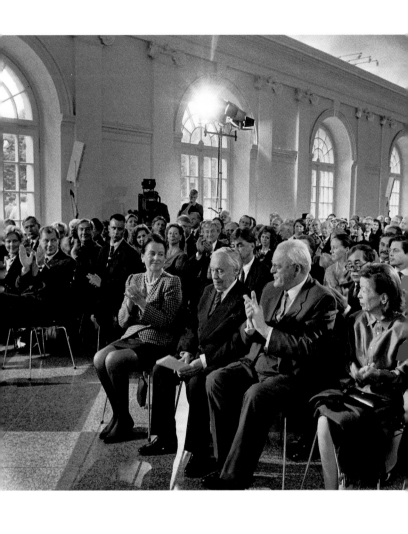

Ceremonial opening of the Berggruen Collection on 6 September 1996 in the Orangery of Charlottenburg Palace (in the front row, from left to right: Ingeborg Knopp, Heinz Berggruen, former German Federal President Roman Herzog and Bettina Berggruen)

Introduction

The question 'Have you been to Berggruen's?' has been commonplace in Berlin since 1996. That is because those who have visited the Heinz Berggruen Collection know what a special museum it is, and are naturally keen to share their delight in it.

So what and where is the Berggruen Collection? Also known as 'Picasso and his Time', it is an assemblage of early modern art – as the title suggests, mostly by Pablo Picasso and his contemporaries, particularly Paul Klee and Henri Matisse – in the Western Stüler Building, directly opposite Charlottenburg Palace.

The building itself is one of two pavilions erected by Prussian court architect Friedrich August Stüler in a fine Prussian late neoclassical style in 1859 to house the palace guards. At the king's behest, the twin buildings were crowned with perfectly symmetrical monoptera, so as to constitute a uniform ensemble with the palace and its dome.

The appeal of the location is obvious. Charlottenburg Palace is set in a splendid park. It and the surrounding buildings now host a rich variety of art collections. Heinz Berggruen was well aware of all that in 1992, when the former director of the Staatliche Museen zu Berlin, Wolf-Dieter Dube, proposed clearing the Western Stüler Building so that the Berggruen Collection could be put on display in Berlin for a few years immediately following its extremely successful stay at the National Gallery in London. The offer included a careful interior restoration of the building by architects Hilmer, Sattler & Albrecht – and was one that the collector could not refuse. Thus, with the help of funds made available by the State of Berlin, in 1995 and 1996 the Stüler Building was restored as a 'tailor-made suit' (to quote Berggruen himself) for his private collection, a unique but intimate assembly of early modern works.

Such were the circumstances that lured Heinz Berggruen back to Berlin, where he was born in 1914 and passed a happy childhood and youth. After studying literature and languages in Grenoble and Toulouse, he returned here to start a literary career, but in 1936 the Nazis forced him out, and he emigrated to the United States. 'I'm back in Berlin, the place of my childhood', was Berggruen's delighted comment at the grand inauguration of the collection on 6 September 1996, in the presence of the German Federal President, 'with the intention and awareness of making a contribution – an intellectual contribution – to the moral reconstruction of my old country, which for 12 years decreed that the art I love was degenerate and was to be rejected.'

Heinz Berggruen in his gallery office in Paris, 1965

Berggruen's collecting activity goes back to the early days of his exile. He first saw works by Klee in San Francisco, and in 1940 bought a watercolour by the artist. For Berggruen, Klee became a kind of artistic remedy for homesickness, and then a lifelong passion. In 1944, the exile returned to Germany as a soldier in the US Army, and in 1945 joined the cultural periodical *Heute* in Munich as a means of boosting the fledgling German democracy. Subsequently Berggruen went to Paris as an American cultural attaché at UNESCO. In 1947, he set himself up as an art dealer in Paris, and from 1950 ran a gallery at 70 rue de l'Université, near what is now the Musée d'Orsay. Even today, there is a plaque commemor-ating the legendary Galerie Berg-gruen.

A crucial factor in his career and success as a gallery owner was Berggruen's personal acquaintance with Picasso, whom he had met through the French poet and essayist Tristan Tzara. Berggruen gained the privilege of an exclusive right to handle the sale of many of Picasso's prints and drawings. For the gallery owner, the apparently limitless versatility of Picasso made him *the* artist of the 20th century. He therefore set about collecting works from all phases of his oeuvre. The same applied to Klee, whose sheer variety likewise fascinated the collector. In Matisse's work, Berggruen valued the absolute harmony of colours and shapes. It was

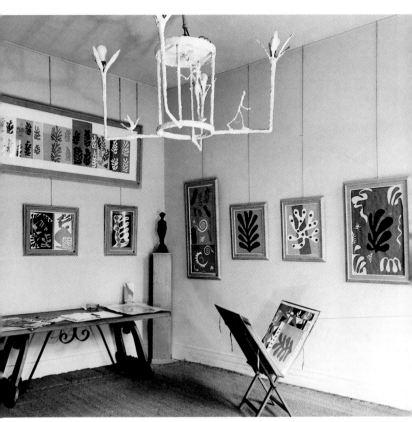

First exhibition of Henri Matisse's papiers découpés, at the Galerie Berggruen in Paris, 1953 (with a chandelier by Alberto Giacometti)

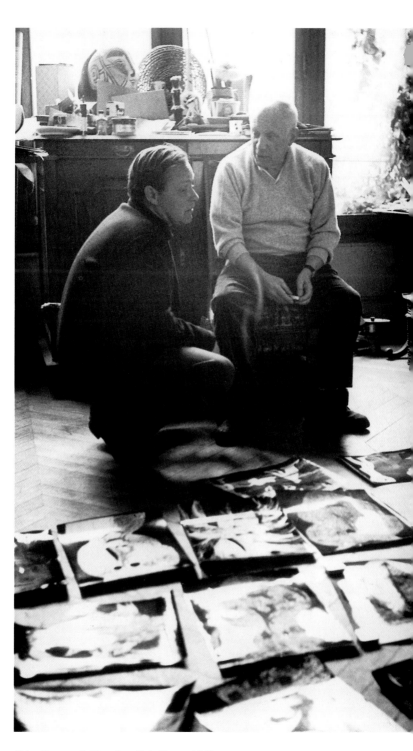

Heinz Berggruen in Picasso's studio in Cannes, 1962

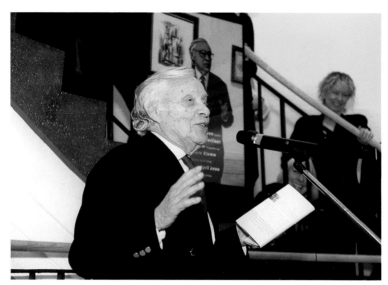

Heinz Berggruen during a book presentation, 1 April 2000

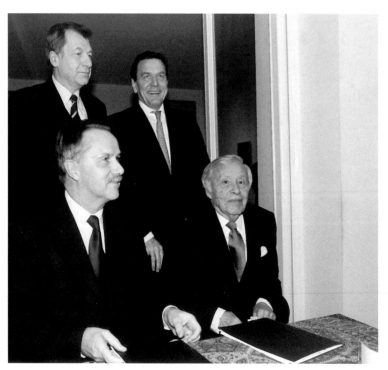

The Berggruen Collection being handed over to the Stiftung Preussicher Kulturbesitz, 21 December 2000 (in the background: the former mayor of Berlin, Eberhard Diepgen, and Chancellor Gerhard Schröder; in the foreground: President of the Stiftung, Klaus-Dieter Lehmann, and Heinz Berggruen)

he who organized the first, extremely successful exhibition of Matisse's near-abstract late work, the *papiers découpés*, in 1953, while the artist was still alive. Finally, in 1980, Berggruen gave up his gallery and devoted himself entirely to his collection.

When the Stüler Building opened to the public as the Berggruen Collection in 1996, it contained 113 paintings, sculptures and drawings, including 69 works by Picasso and 27 by Klee, in addition to works by Paul Cézanne and Vincent van Gogh as key predecessors of Picasso. After Berggruen and his family had decided that the well-received presentation of the collection (visited meanwhile by over 1.5 million people) should become a permanent fixture of the Staatliche Museen zu Berlin's Stüler Building, he single-mindedly set about reforming and expanding his collection. All works by precursors of Picasso were sold off to settle inheritance matters. The collections of works by Picasso, Klee and particularly Matisse, on the other hand, were expanded to include some important purchases, such as Picasso's *Large Reclining Nude* of 1942 (no. 28). During its time in Berlin, therefore, the collection has grown by almost a third, and now comprises 165 works, including 89 by Picasso, 52 by Klee and 14 by Matisse (making it the largest Matisse collection in any German museum). The collection was rounded off with pictures by Georges Braque and sculptures by

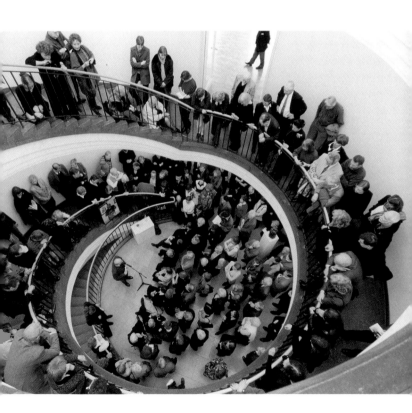

Stairwell in the rotunda of the Berggruen Museum (Western Stüler Building), April 2000

Peter-Klaus Schuster and Heinz Berggruen at the ceremony conferring an
honorary doctorate on Werner Spies at the Kunsthistorisches Institut of Berlin's
Free University, 7 May 2003

Alberto Giacometti and Henri Laurens, plus rare examples of African art.

On 21 December 2000, the ownership of Berggruen's 'Picasso and his Time' collection was transferred to the Stiftung Preussischer Kulturbesitz for a nominal amount paid jointly by the Federal Government and the government of Berlin. The return of the collector to his native city together with his collection thus produced a splendid outcome for Berlin and its friends. Berggruen's private collection, amassed over 50 years, mostly in Paris, passed into permanent public ownership in the new-old German capital. 'For this,' said Gerhard Schröder, the Federal Chancellor, at the signing of the contract of transfer, 'we owe you and your family our profound, heartfelt thanks, Mr Berggruen.'

Peter-Klaus Schuster

Director General of the
Staatliche Museen zu Berlin
Preussischer Kulturbesitz

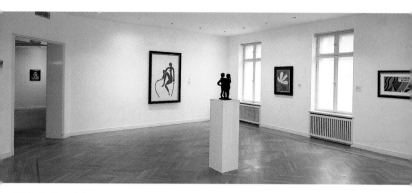

Works by Henri Matisse

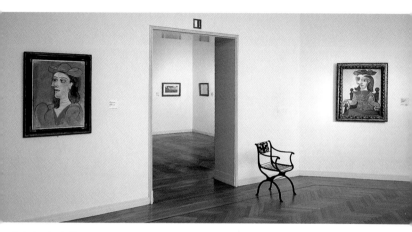

Paintings by Pablo Picasso

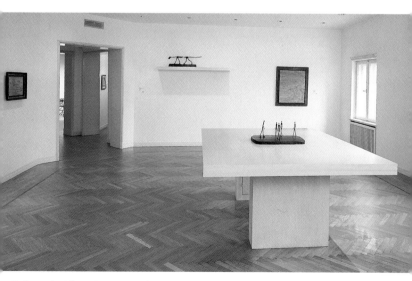

Sculptures by Alberto Giacometti and paintings by Paul Klee

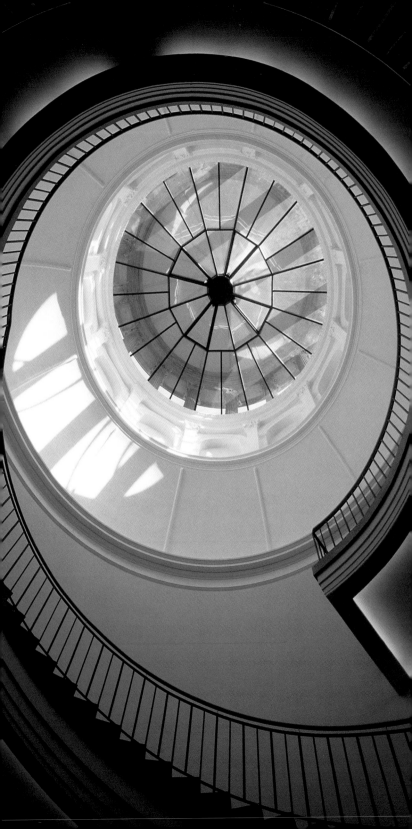

The Principal Works in the Collection

Pablo Picasso (1881–1973)
Nos. 1–7, 10–14, 16–34

African Art
Nos. 8–9

Georges Braque (1882–1963)
No. 15

Alberto Giacometti (1901–1966)
Nos. 35–36

Paul Klee (1879–1940)
Nos. 37–58

Henri Matisse (1869–1954)
Nos. 59–66

View from the ground floor up through
the rotunda in the Berggruen Museum
(Western Stüler Building), 2000

The authors

MK Melanie Klier
RM Roland März
HJP Hans Jürgen Papies
DS Dieter Scholz

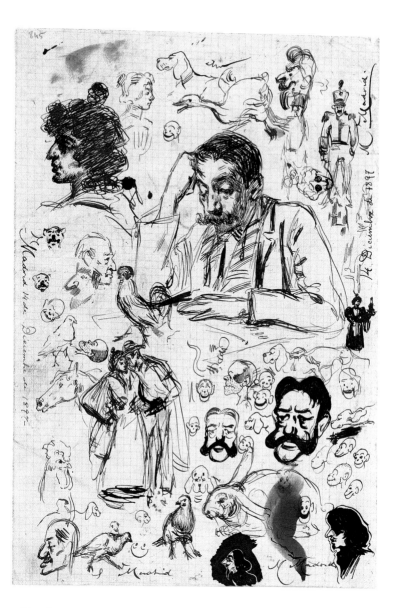

Pablo Picasso (1881–1973)

1 *Study*, 1897
Pen and ink on graph paper,
30.5 x 20.7 cm

Dating from 14 December 1897 in
Madrid, this study is the earliest work
by Picasso in the collection. By then,
he was 16 and enrolled at the Aca-
demy of San Fernando. Picasso's great
gift had been recognized early on and
encouraged by his father, who was a
drawing teacher. What could be
taught he had already largely assimi-
lated, so that his main interest lay in
freehand sketches of people and ani-
mals in parks and cafés, as this study
bears out. HJP

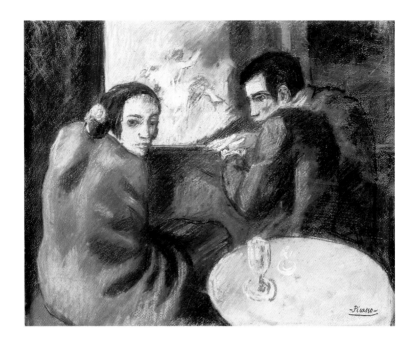

2 *In the Café*, 1902
Pastel on card, 31 x 40 cm

In the early years of the 20th century, Picasso divided his time between Paris and Barcelona. His parents had lived in the Catalan capital since 1895, and many echoes of it would resurface in his work throughout his life. This was the place where the precocious artist had had a liaison at only 15 with circus rider Rosita del Oro, who was nearly twice his age. But especially important for him was the cabaret restaurant Els Quatre Gats, where Catalonia's avant-garde gathered in a fever of Modernisme. As an Andalusian by birth, he was initially an outsider, but soon found not only friends such as Jaime Sabartés but also ideas for his work. The subject matter from the everyday life of ordinary people and the mono-chrome Blue Period that began towards the end of 1901 had their roots in this phase of his life. In early 1902,

Picasso returned to Barcelona after his second spell in Paris, and that is when this drawing (also called *Scene in a Café-Concert*) came into being.

The young couple in the café, who had been watching the dancer on the stage in the background, have just turned away. Their rather chilly attitude creates a marked distancing effect from the viewer. The young, self-absorbed woman looks vacantly ahead. The man stares at her posses-sively, with a rather furtive gaze and aggressively arched back. The tension between the couple, their solitude in their togetherness and their apparent apathy is charged with powerful symbolism.

This pastel drawing meant so much to Picasso that he took it with him to Paris at the end of the year for his exhibition at the Galerie Berthe Weill. HJP

3 *Portrait of Jaime Sabartés*, 1904
Oil on canvas, 49.5 x 37.5 cm

Born in 1882 in Barcelona, Jaime Sabartés was a moderately talented writer who enjoyed moderate success. He made Picasso's acquaintance around 1898/99 through the Els Quatre Gats *habitués*, and was drawn to him as someone he greatly admired. Between then and 1904, the year he went to South America (returning in 1935 to become Picasso's secretary), Picasso did several portraits of him,

the last being this half-length picture entirely in blue dating from April 1904. Legend has it that Picasso painted it after an ill-tempered evening spent in a train, and worked off his foul mood in this picture. Even Heinz Berggruen, who made Sabartés's acquaintance as late as 1950, noticed the 'decidedly severe, sharp features' – they reminded him of an 'inquisitor's portrait by El Greco'. Recently discovered in Picasso's estate is a photographic portrait of Sabartés that obviously served as a model. HJP

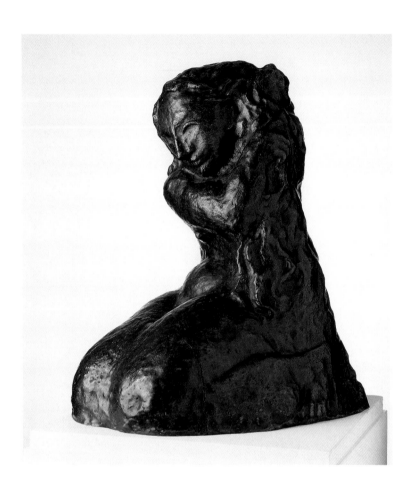

4 *Woman Combing her Hair*, 1906
Bronze, 42.2 x 26 x 31.8 cm

It long remained unknown that Picasso also produced an extensive sculptural oeuvre, even though the earliest piece dates back to 1902 in Barcelona. The impetus for a *Woman Combing her Hair* came mainly from Paul Gauguin's works, particularly *Oviri*, a ceramic of 1894. Picasso likewise did the work initially as a ceramic, the bronze being cast later.

However, the more direct inspiration was Fernande Olivier, Picasso's first great love, whom he had been living with for a year and whom he delighted in watching when she combed her red hair in the morning.

Even though the sculpture initially looks completely in the round with its solid volume, it is nonetheless developed from a lateral perspective to produce a flowing silhouette. The back part is left hollow. The crook of the right arm leads over the pyramidal plinth, on which the left leg is treated in relief, into the combing gesture. The long hair flows gently across the softly modulated body. The face remains turned inward, relaxed. As in the Pink Period generally, the treatment is not psychological. HJP

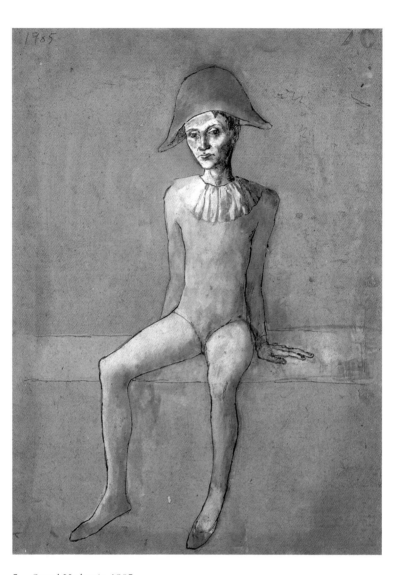

5 *Seated Harlequin*, 1905
Watercolour and ink on art card,
57.2 x 41.2 cm

The harlequin is a figure from the
theatrical world. Subtle changes of
pose are part of his profession. Here
he appears seated, resting on his hands,
on what appears to be a balustrade,
apparently floating rather than sit-
ting. But his 'real' face looks tired and
melancholy. The head is worked up
in detail, with hard, short, contrasting
brushstrokes and white highlights,
while the faded jersey on the boyish
figure has a sketchy diamond pattern
in delicate pink and blue. Otherwise
the pen has traced only an outline.
The work was done in early 1905 at
the beginning of the Pink Period,
though the bright red of the back-
ground is still steeped in the dramatiz-
ing spirit of the Blue Period.

HJP

Pablo Picasso (1881–1973) 23

6 *Head of a Woman*, 1906–07
Red chalk and black ink on paper,
62 x 47 cm

7 *Female Nude* (study for *Les
Demoiselles d'Avignon*), 1907
Oil on canvas, 81 x 60 cm

Among the outstanding works
Picasso did in this first decade in
Paris, one painting is seminal both for
his early work and for 20th-century
European art history generally. This
is *Les Demoiselles d'Avignon* of 1907,
now seen as the incunabulum of
Cubism. Picasso began work on
preliminary studies for it in 1906, and
a total of 500 works ranging from
simple pencil sketches to oil studies
were executed in preparation of the
final work. The Berggruen Collec-

tion has four of them – the *Nudes* of
1906, which marks a break with the
European ideal of beauty, the red
chalk drawing *Head of a Woman*
(1906/07), which impressively
demonstrates the 'non-psychological
approach' (Werner Spies) Picasso
took during this period, the *Sailor
Rolling a Cigarette* (1907) and, most
notably, the *Female Nude*, a study for
the right-hand background figure
in the final painting.

Undoubtedly a retrospective of
Cézanne's works Picasso had seen in
Paris in 1907, particularly the picture
of the *Bathers*, exerted a considerable
influence on Picasso's large-format
group picture. His long-standing no-
tion had been to group five prosti-
tutes (here he was apparently draw-
ing on his memories of the familiar

Carrer d'Avinyó red-light district of Barcelona) around the cigarette-rolling sailor and confront them with a medical student pointing out the dangers of syphilis, which would have turned this brothel scene into a memento mori, but he abandoned the idea after an encounter with African art, which impressed him deeply.

Following this new direction, he disfigured the heads of the two right-hand figures, contrasting them with the three figures on the left, which conform with European notions of beauty. The present oil study, in particular the geometricized outlines of the figure, reveals the artist's stylistic link with Cézanne more clearly than the final work. The free application of paint and the highly expressive faces are, however, more reminiscent of the work of Van Gogh, and indeed of African masks.

HJP

Pablo Picasso (1881–1973) 25

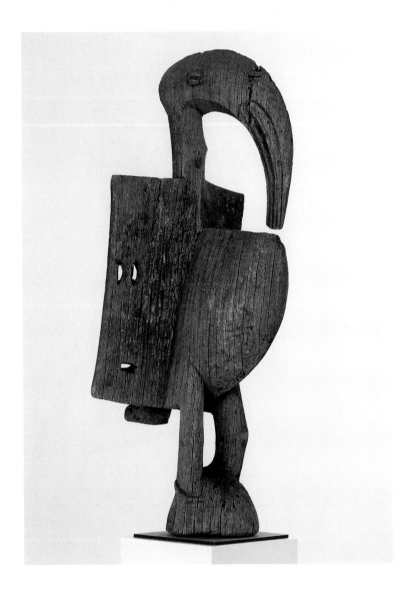

African Art

Senufo, Korhogo Region, Ivory Coast
8 Large calao bird
19th/20th century
Wood, 149 x 57 x 64.5 cm

Southern Kota, Gabon/Congo Republic
9 Reliquary figure
Wood with appliquéd copper, brass, tin and
sheet iron, 81 x 37 x 16 cm

That five objects of African art are
included in a collection oriented so
heavily towards European Modern-
ism can be explained by Picasso's
studies for *Les Demoiselles d'Avignon*
(see no. 7).

African objects are not a priori
autonomous works of art. They were
created to serve a purpose within an
ethnic culture. Starting from a basic
type, endless variants were created,
though they varied in quality.

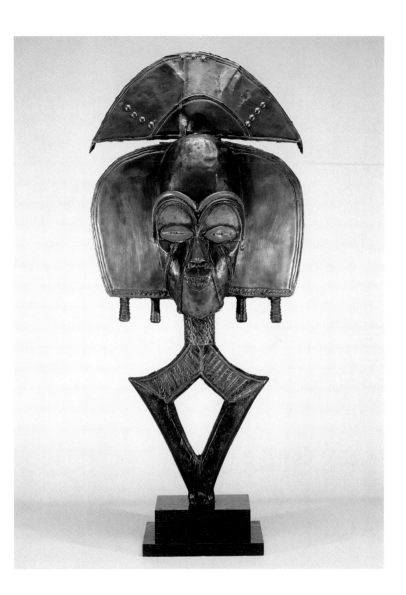

For the Senufo in the Ivory Coast, the calao, a type of hornbill living in the savannah, is a sacred bird that is believed to have been one of the earth's first inhabitants. Sculptures of it are symbols of fertility. Kept in sacred groves, they are worn on the heads of young men during certain ritual dances.

The Kota, who live mainly in east Gabon and adjacent areas of the Congo Republic, have since time immemorial practised ancestor worship. The mortal remains of notables are laid in woven reliquaries, and these are watched over by anthropomorphic guardian figures of this kind. The flattish sculptures are carved from wood, and metals of various colours are appliquéd to the front. HJP

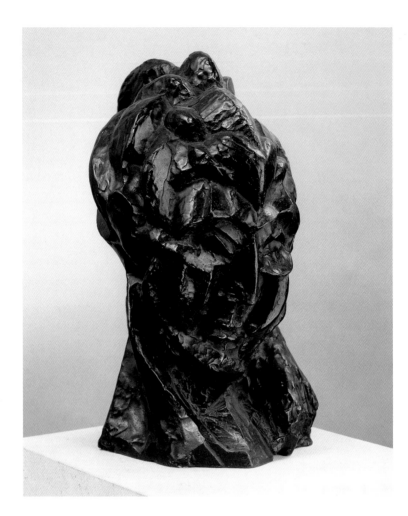

Pablo Picasso (1881–1973)

10 *Head of a Woman*
(Fernande), 1909
Bronze, 42 x 23 x 23 cm

This portrait in the round of Picasso's partner Fernande Olivier dates from autumn 1909 and shows the artist coming to terms with a basic problem of Cubist form, viz. the fragmentation and rearrangement of shapes. From the spring of that year, he had been working on the problem in quite a number of canvases. Now, returning from a creative spell in Horta de Ebro, he was ready to apply the analytical Cubist approach to sculpture.

The most obvious feature is of course the multiple viewing angles, but closer study reveals a complex system of convex and concave faceting and dismembering in an interlocking network of curves and transitions. The mouth, nose and eye cavities have roughly their natural dimensions, but the cheeks have been subjected to the full analytical treatment. Thus, although Fernande's head has been turned into a depersonalized art object, the bronze nonetheless shows it to be an indissoluble structural entity. MK

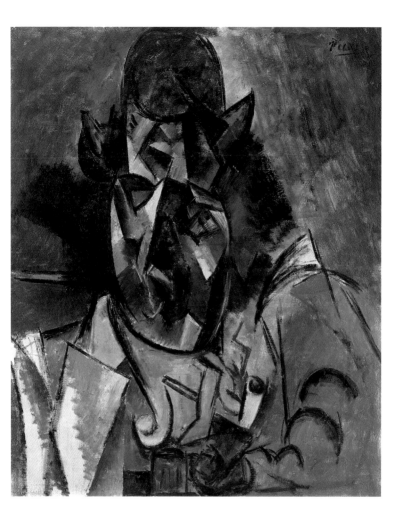

11 *Portrait of Georges Braque,*
1909–10
Oil on canvas, 61 x 50 cm

The history of the portrait of
Georges Braque is as uncertain as
the picture's formal idiom, which be-
longs to the 'analytical' phase of Cu-
bism. By the winter of 1908 and fol-
lowing a visit to a Braque exhibition
at Daniel-Henri Kahnweiler's gallery,
Picasso had overcome the initial re-
sentment he harboured towards the
young Frenchman for his supposed
intellectual theft and was both on
good terms and in frequent commu-
nication with him.

 Three elements have a decisive
effect on the central pictorial event –
the dissolution of the subject and his
oval face into geometrical shapes, the
break-up of outlines (right arm) and
the brown coloration of the whole
picture. It is noticeable that the figure
and background are not as closely
interwoven as those in the famous
abstract portraits of the art dealers
Wilhelm Uhde and Kahnweiler.
Despite the Cubist stylization,
Braque as an individual can still be
made out by means of the realistic
detail of the hat (more specifically,
a bowler). Picasso himself said of the
picture that it was 'made without a
model. Only later did Braque and
I pretend it was a portrait.' MK

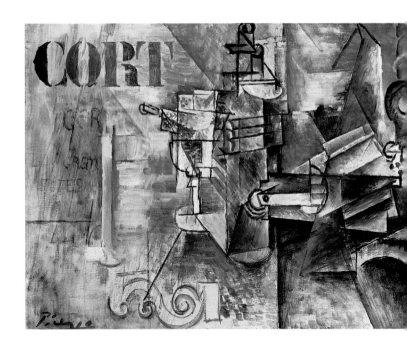

12 *Bottle, Absinthe Glass, Fan, Pipe,*
Fiddle and Clarinet on a Piano,
1911–12
Oil on canvas, 50 x 130 cm

This fragmented world of objects was
created by Picasso at the beginning
of his phase of Synthetic Cubism
(1912–14). That much is evident
from the much greater variety of as-
sociations that the picture evokes in
the viewer in contrast with the visual
effect of Abstract Cubism and the
more vivid coloration. It was
presumably an ultimately uncom-
pleted, commissioned work for the
collector Hamilton Easter Field that
prompted the use of the elongated
landscape format. Field had ordered
wall pictures for his library in New
York. As the dimensions of the wall
correlate with those of the still life,
it seems reasonable not to rule out
this connection.

As far as the inner logic of the
picture is concerned, it is clear that –
despite the rather abstract character
of the large composition – Picasso

integrated into the picture as a whole
realistic associations with external
reality. We can make out fragments of
various objects seen from different
angles or broken up into individual
shapes. We can, for example, distin-
guish a piano in the middle and right
half of the picture – but the keyboard
is sundered from it and pushed into
the lower foreground. Picasso took
the 'fanning out' of the fan quite lit-
erally. The picture as a whole opens
up a panorama of geometricized
shapes. We encounter the strings,
neck and innards of the violin as or-
namental fragments. Do the green
brushstrokes on the left-hand edge
conjure up the 'green fairy', the
mind-stupefying absinthe or the glass
of a bottle?

Absinthe glass and bottle, pipe and
clarinet are multiply fractured. Up-
turned and revolved, the objects cre-
ate a rhythmic composition; they
come together, break apart, create
highlights – just like a piece of music.

What is vital is that Picasso's
painting is a testimony to his artistic

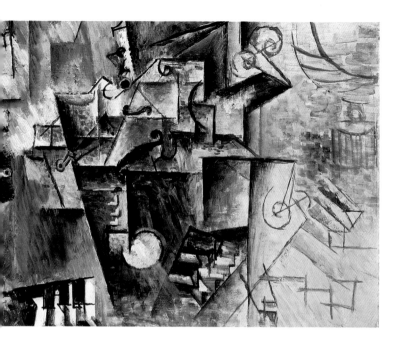

collaboration with Braque. The two painters spent part of the summer of 1911 together in the village of Céret. Braque's recollection was 'as if they were in the mountains hanging on the same rope'. The initial evidence of this interaction between the artists is the treatment of surfaces, with flattened formal planes and colour fields. Despite the black outlines of surfaces, foreground and background seem interwoven on account of the coloration and rhythmicized brushstrokes. Time and again, the short, staccato-like brushwork and greywhite smeared colours convey the impression of masonry, wall painting or wood grain, i.e. different types of surface. (It was Braque who, as a trained interior decorator, introduced wood into the Cubist dialogue, using the technical trick of the painter's comb and imitation.)

Another aspect of the partnership between the two was that Braque incorporated letters into his paintings, especially in 1911: 'These were shapes that could not be changed.

Being flat, letters stand outside space, and with their presence in the picture, objects within the space could be distinguished from those outside it.'

Picasso adapted this idea. But in early 1912, he gave his painting additional import with letters, especially by integrating the word 'CORT'. This was in the first place a reference to the pianist Alfred Cortot, and parallels a painting by Braque, who by including the names 'MOZART' and 'KUBELIK' in his works had created a connection with a musical event. The use of such precise allusions and musical symbols brings specific musical sounds, as it were, into the visual space.

Moreover, the use of letters in Picasso's still life represents a step towards artistic autonomy. The objects and letters are not so much subordinate to an overall structure imposed by reality as an independent system of symbols within the picture. MK

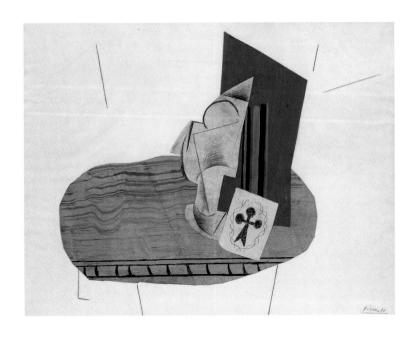

13 *Glass and Ace of Clubs*, 1914
Pencil and *papiers collés* on paper,
48 x 63 cm

Dating from early 1914, this piece is a good example of Cubist *papiers collés* (pieces of paper attached to a work of art), which would lead to the concept of collage. In 1912, Picasso and Braque had evolved a 'synthetic' method as a new kind of Cubism. As part of this development, it was the next logical step to cut largish areas out of other materials and affix them to the picture. During this period, Picasso and Braque resorted to this artistic technique as often as to oil painting.

What strikes the eye first about the *Glass and Ace of Clubs* is the simplicity of the composition. There is a large oval in the lower half of the picture on a white paper background. Above it in the right-hand half is a shape made up of three parts, such that the difference between horizontal and vertical shapes is further emphasized by the contrast between warm and cool colours.

Yet the 'meaning' of works in the 'synthetic' period is not limited to formal relationships. In the *papiers collés*, the references to reality tend to increase. Thus in this work, the glued-in pictorial parts combine to form a still life, which is typical of Cubist iconography. A cut-out oval of card with imitation wood veneer constitutes the table. A drawn playing card takes the eye across the table like a hinge to the 'objects' lying on the table. A rising shape, with a contour drawn on white undercoated canvas and cut out, bears a certain resemblance to Picasso's Cubist sculpture *The Absinthe Glass* dating from around the same time (see no. 14). The still life is completed by an almost conical piece of canvas painted blue-grey that probably represents a faceted carafe. HJP

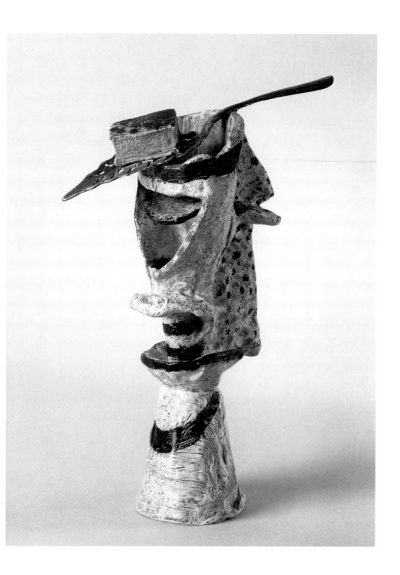

14 *The Absinthe Glass,* 1914
Painted bronze with absinthe spoon,
22 x 15 x 7.5 cm

Absinthe is an alcoholic drink made
from wormwood, and until about
1914 was highly popular. Thus the
absinthe glass itself became the sub-
ject of pictures, particularly in
Picasso's oeuvre (see nos. 2, 12, 13).
In early 1914, he depicted it as a
three-dimensional object in the
Cubist manner, i.e. with fractured,
geometrical shapes and reflections

(the 'missing' bit of the side of the
glass hints at a reflection).

Two innovations by Picasso make
the work of major significance: first,
though six identical bronzes of it
were cast, they are differently painted
by Picasso, making each piece in the
series unique; secondly, for the first
time an ordinary, everyday object (a
real absinthe spoon) is integrated into
a work of art. The only other work in
the series still in Europe is in Paris.

HJP

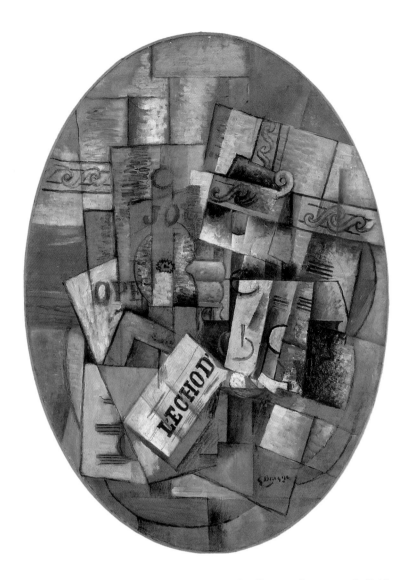

Georges Braque (1882–1963)

15 *Still Life with Glass and Newspaper (Le guéridon)*, 1913
Black chalk, charcoal and oil on canvas, 98.7 x 72.5 cm

This oval, 'faceted' painting is a significant work in the development of Synthetic Cubism. The title refers to features of two objects that induced Braque to reconsider the function of symbolic items – the glass for its material transparency and print for creating the illusion of a message. Individual fragments of words, such as 'jour', 'open' or a newspaper title, are assembled in superimposed layers of colour, written over the rectangles shaded white, grey and brown and bordered with black lines. Arcs, ornamental friezes and wood graining break through the abstract Cubist structure as 'real' and yet defunctionalized elements, though without destroying the impression of flatness and overlapping. MK

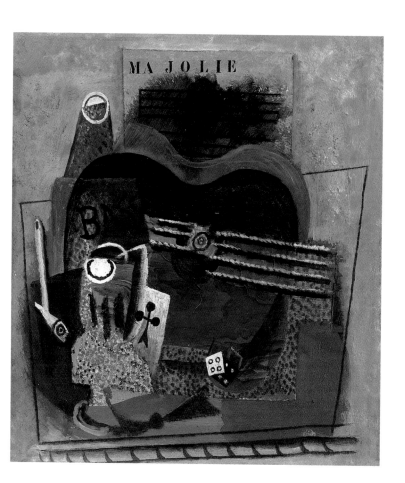

Pablo Picasso (1881–1973)

16 *Ma Jolie*, 1914
Oil on canvas, 45 x 41 cm

This composition may indeed consist of the usual requisites of Cubist iconography, but it nonetheless exudes a new approach compared with previous still lifes. The outbreak of World War I brought to an end the shared development of an austere 'orthodox' Cubism. Picasso, for his part, took Cubism one stage further, making it more colourful, spacious and even literary.

An even greater influence in this respect may have been the arrival of Eva Gouel in 1912. A small, rather pale beauty with pointed breasts and a dash of Parisian pertness, she managed by intrigue to lure the sexually driven Picasso away from the side of her friend Fernande. Though Picasso did no 'portraits' (in the literal sense) of this 'Eva', he dedicated a large number of his still lifes to her under the guise of *Ma Jolie*. The words appear in this picture, too, over a sheet of music. And there's a guitar to play the music to her, in the form of two hearts, one behind the other. The intense green (hope) coupled with the presence of dice and playing cards could suggest the uncertainty of destiny. Eva died of cancer in December 1915.

HJP

17 *Man Seated at the Table*, 1916
Gouache on paper, 27.5 x 21.7 cm

'Paintings are nothing but exploration', Picasso had stressed, 'and there is a logical development in all this probing.' This gouache is likewise a 'logical development', particularly within the context of *papiers collés*, *periode cristal* and contemporary discussions about costume designs for the ballet *Parade*.

An abstract figure with a blue top hat and face in profile can be discerned against a yellow wall with a black door. The painting is clearly composed. Blocks of colour are strictly systematized, parallelized and superimposed in orderly fashion. This layering process recalls the collage technique of *papiers collés*. Dotted and screened surfaces contrast with monochrome blocks. At the same time, the combination of styles anticipates the costume of the American manager in *Parade*. And the patterned rectangles evoke the torrent of windows in skyscrapers.

The works around 1916 show the artist taking pleasure in both figurative detail and the purely technical 'logical developments'. MK

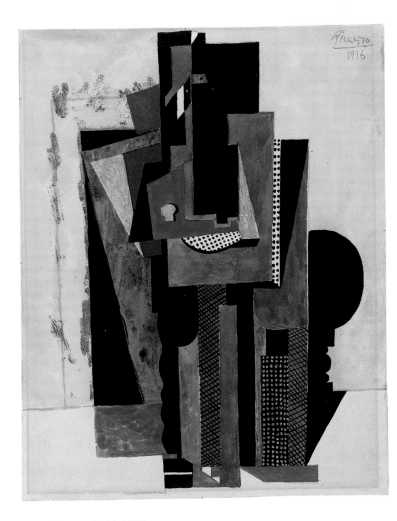

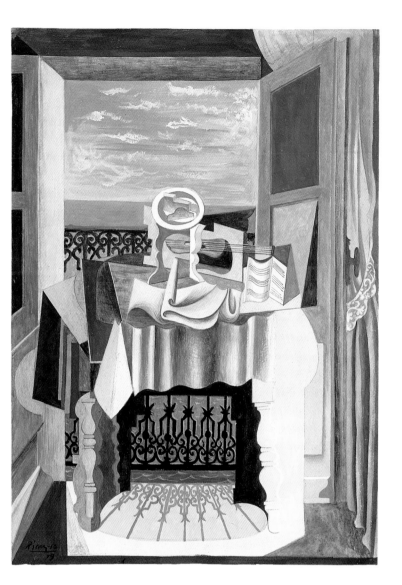

18　*Still Life in front of a Window in St Raphaël*, 1919
Gouache and pencil on paper, 35.5 x 25 cm

Picasso spent the hot summer months of 1919 with his young wife Olga at the Côte d'Azur seaside resort of St Raphaël in France. From their hotel room, with its French windows, Picasso did a series of drawings, watercolours and gouaches. There was generally a small table in front of the window, as in this gouache, the repository of a number of everyday objects and a musical instrument. On closer inspection, the initial impression of Rococo sunniness yields to a surreal, rather chilly atmosphere compounded by Cubist complexity in the treatment of objects. In his book *Picasso: From the Ballets to Drama, 1917–1926* (1999), Josep Palau i Fabre suggested that this gouache might more appropriately be called 'The Blue Sea Permeates the Room'.　HJP

19 *Portrait of a Woman, c.* 1923
Glass sand and binder on canvas,
55 x 45.7 cm

We do not know whether this picture is based on a particular woman or a classical statue. The notion of a sculpture, especially one in sandstone, is evoked to the extent that this 'painting' is made entirely of sand fixed to canvas with an agglutinate. Unusual, 'real' materials were employed even in earlier Cubist paintings and *papiers collés*, but here Picasso dispenses with oils as well. This is more systematically done than in
two other portraits of women in this technique, likewise from around

1923. On the 'blackened' ground he uses sand to form a kind of relief. Picasso may have been prompted to do this portrait of a woman, about which there is a palpable sense of melancholy, by a stay in Fontainebleau in 1921, possibly after seeing a sculpture in the park.

William Rubin's view is that the portrait represents Sara Murphy, a friend who with her husband, Gerald, spent the summer of 1923 with Picasso and his wife Olga in Antibes on the Côte d'Azur. HJP

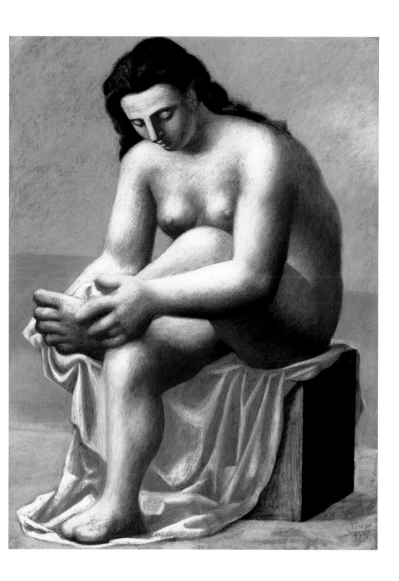

20 *Seated Nude Drying her Foot,*
1921
Pastel on paper, 66 x 50.8 cm

Even though the subject itself goes
back to the classical sculpture of a
thorn being plucked, the original of
which Picasso had seen during his
visit to Rome in 1917, the painting
was more directly inspired by Au-
guste Renoir's *Woman Bathing, Seated
in a Landscape* (1895/96). A compari-
son between the painting and the

pastel reveals considerable overlap in
composition, though reversed, as
mirror images of each other. More-
over, the sensual charm of Renoir's
woman is not entirely absent from
the likewise plump female figure Pi-
casso paints. The difference lies mainly
in Picasso's figure being placed in a
rather chilly sea setting, and also that
the neoclassical idiom he resumed in
1914 is distorted by monumen-
talization in the depiction of the
hands and feet. HJP

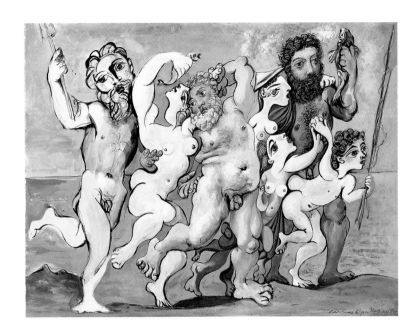

21 *Silens Dancing*, 1933
Ink and gouache on paper, 34 x 45 cm

Picasso and myth (and mythology) is a big subject. In this gouache of 6 July 1933 we are shown the mythological figures of silens, elderly satyrs known for the delight they took in crude Dionysiac pleasures, insatiable lust and voluptuous dances with nymphs. Picasso has them here as followers of Neptune. They are seen embracing four nymphs as they run lustily across the seashore catching fish. A significant aspect of this prancing roundelay of figures is the flesh tone of the male figures, which intensifies from left to right – a 'metamorphosis' from the sketched left-hand figure outlined in ink (Neptune with his trident) through to the carnal bearded right-hand figure holding up a fish in his left hand. The pale, plaster bodies of the naked women form a stark contrast.

The dance motif has always been thought to be the result of Picasso's work for the Ballets Russes, and harks back to the gouache depicting the young women from Dinard running across the shore (1922). But a more informative view is that the picture is Picasso's reaction to Poussin's *Bacchanal* of 1633. In favour of this interpretation are the variations on Old Masters in Picasso's oeuvre (and Poussin himself, in the *Triumph of Pan* of 1944) and specifically the paraphrasing of the roundelay and chiaroscuro contrast.

In 1931, Picasso had illustrated Ovid's *Metamophoses*, and here he is likewise playing with the concept of metamorphosis (which he saw as the artist's real job), making use of it both graphically and as subject matter. This allowed him to make use of the myth and explore a personally sensitive subject. Analogies with the picture *The Sculptor and his Work* done a few days later in Cannes are evident (head of the sculptor plus the profile of a young woman with a hat as the head of Marie-Thérèse Walter). Through these pictures shines the biographical background of a time caught between the bliss of love and troubled summer days. MK

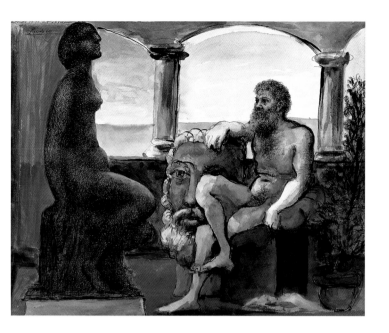

22　*The Sculptor and his Work*, 1933
Watercolour, gouache and ink on paper,
39.5 x 50 cm

Fifty etchings of the *Vollard Suite* alone, which Picasso worked on from 1930 to 1937, relate to the subject of this picture, namely the sculptor and his model. The focus here is on the sculptor, but the gouache also clearly alludes to the mythological figure of Pygmalion, who sought to create the perfect wife.

As the classical figures show, Picasso is still preoccupied with myth, dressing up for it as well. In this case, the real masquerade consists of a multi-layered, symbolic reflection of the artist's self-portrait and a private visual world – the gouache was painted on 20 July during the family holidays in Cannes. At the time, quarrels between Picasso and his wife Olga were becoming frequent. His inspiration and muse was now his young mistress Marie-Thérèse Walter. The picture can therefore be placed four-square in a context of tensions between idyll and dishar-mony.

Seated on his veranda with a view to the open sea, the sculptor gazes pensively at his work – a sculpture of Marie-Thérèse with her pure Greek profile, 'statuesque beauty' and figure attesting to the 'purity of line' (Françoise Gilot). That he can do this with an extra eye – that of the large terracotta head – alludes to the proper way art should be seen, and ultimately to Poussin (cf. no. 21). Moreover, Picasso has his sculptor casually rest his hand on the head of Zeus as an explicit reference to antiquity.

In Poussin's *Self-portrait* of 1650, the allegory of painting wears an eye as a diadem on her head, in which Oskar Bätschmann recognizes 'nat-ural sight (the visible)' and the 'per-spective view (the invisible)'. In this context, Picasso's preoccupation with Ovid's *Metamorphoses* gains new force. The metamorphoses take place in front of us – and oscillate for Picasso, the artist, between different media: the female body of Marie-Thérèse may be a sculpture, but at the same time she is a pen drawing that resembles an etching.　MK

Pour mon ami Berggruen

picasso

23 *Minotauromachia*, 1935
Etching, 49.6 x 69.3 cm

The minotauromachia is a subject drawn from Greek mythology, and means the battle with the Minotaur. The story is that Pasiphae, the young wife of the elderly King Minos of Crete, fell in love with a handsome bull and indulged her passion for it. Some time later she gave birth to a human with a bull's head, who was called Minotaur. The Minotaur was confined to a dark labyrinth, and every seven years demanded a human sacrifice.

Even though the title of this etching does not come from Picasso himself, we can assume that he had the story in mind when he conceived it, but his intention was far from merely illustrating it. To him, it represented a first step towards an 'individual mythology'. When he began working on the copper plate on 23 March 1935, completing the work about a month later, he was in a state of profound depression. A few months ear-

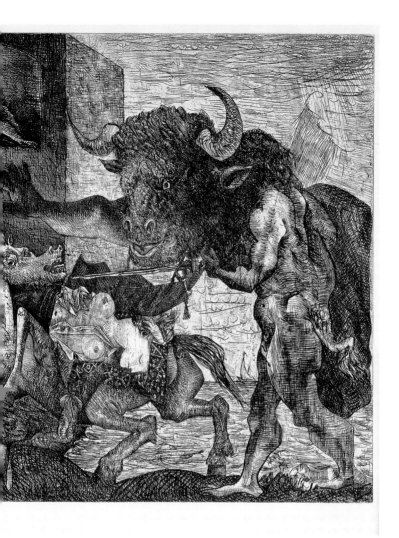

lier he had separated from his wife Olga, and his young mistress Marie-Thérèse Walter, whom he had met in 1927, when she was only 16 years old, was expecting a child by him. This complex and depressing situation obviously made its mark on the creation of this etching.

But it cannot be reduced to merely biographical aspects. There have been many widely different attempts at interpreting this work – one of Picasso's graphic masterpieces – but the actual message remains unclear.

There is general agreement that Picasso depicted himself in the figure of the Minotaur and Marie-Thérèse in the girl holding a candle. But who, then, is the topless torera lying on the slit-open body of the horse?

There has similarly been no shortage of interpretations of a more philosophical kind, either. For example, the Minotaur is seen as a force of nature that bursts in on mankind, which reacts to it in quite different ways. HJP

24 *Head of a Faun*, 1937
Ink, pastel and wax crayon on paper,
27 x 21 cm

It is very likely that Picasso knew
Claude Debussy's *Après-midi d'un
faun* composed in 1890, and he may
have been inspired by it when he did
the *Faun Uncovering a Woman* aquatint
in 1936 (included in the *Vollard Sui-
te*). Figures from classical mythology,
fauns are often equated with the
cloven-hoofed god of nature, Pan,
and considered to be lecherous and
brimming with animal fertility. In so-
me ways, they were akin to the
Minotaur (see no. 23).

In this drawing, dated 1937,
Picasso focuses on the head, which is
similar to the contemporary portrait
of Dora Maar. Yet with its clashing
but shimmering colour combination
of violet, green and yellow against a
dark background, this picture con-
jures up an image of a demonic play-
boy complacent with the certainty
of triumph. HJP

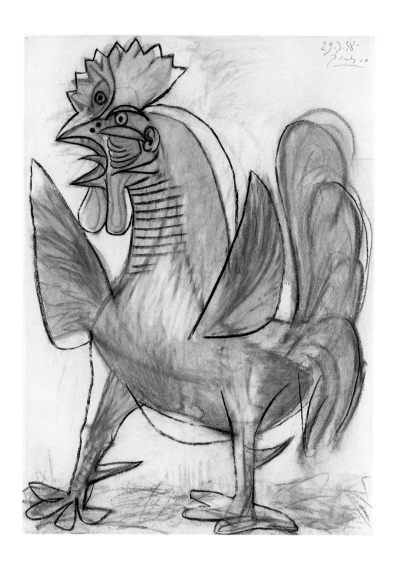

25 *The Cock*, 1938
Charcoal and pastel on paper,
76 x 56 cm

Picasso liked animals. This much
seems evident from the frequent
appearance of animals in his works.
However, the cock motif is rather
rare. After a number of sculptures in
the early 1930s came the large-for-
mat *Woman with Cock* painting of
February 1938, in which a cock is
lying on its back with its legs tied and
a woman on the point of slaughter-

ing it with a knife – a metaphor for
the destruction of helpless humanity.

A month later Picasso did five
drawings of individual cocks, includ-
ing this pastel drawing. In this pic-
ture, the animal appears ready to fight,
standing firmly on both legs, its
feathers fluffed up and neck arched.
The eyes are depicted in the Cubist
manner. The tongue projects as a
dangerous barb from the gaping beak.
Picasso leaves it quite open whether
this cock is also a metaphor. HJP

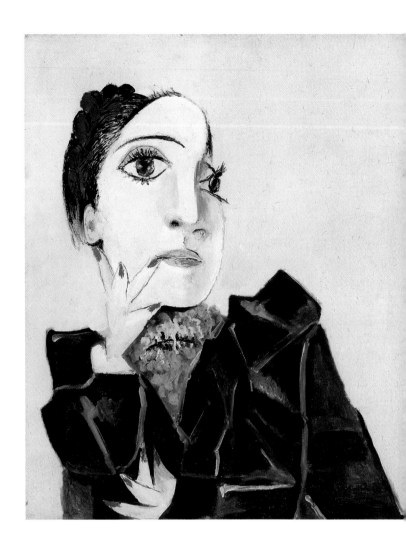

26 *Dora Maar with Green Fingernails*, 1936
Oil on canvas, 65 x 54 cm

27 *The Yellow Pullover*, 1939
Oil on canvas, 81 x 65 cm

Picasso and Dora Maar apparently first met at the Deux Magots café in Paris in early 1936, and were at once strongly attracted to each other. Picasso was then 55 and world-famous. Dora Maar was 29 and an acknowledged photographer, at least among the Surrealists.

What was it about her that appealed to him? Paul Eluard was struck by her 'whole beauty and great intelligence'. According to Victoria Combalía, with her 'wasp waist, wide hips, opulent rump and shapely legs', she represented Picasso's ideal woman.

He did his first pictures of her in November 1936, including the portrait of her with green fingernails. She sits here in an armchair, her upper body and the grave oval of her head above it inclined leftwards, thus softening her rather hieratic posture. The head is slightly in profile and

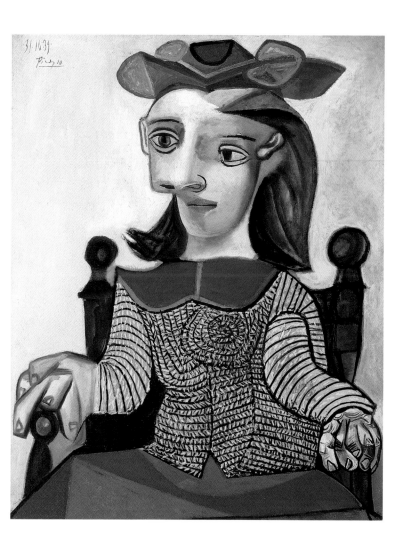

with the Spanish hairdo emphasizes her classical features, while the spread fingers with the green-lacquered nails underline the elegance of this capricious woman.

Four years later, following the outbreak of war, Picasso had fled to Royan on the Atlantic coast to escape the invading German army. There he continued working, despite living with Dora in the confined space of a hotel room. In October 1939, he painted *The Yellow Pullover*, another portrait of her, but in this case it is not so much about individual aspects of her personality as a symbol of the time. Again, Dora sits plumb centre in the wicker chair. The head is stylized with a double face (frontally and slightly in profile) in the Cubist manner, and looks almost classical. In the deforming circumstances of the time, the body is confined in a tight 'yellow pullover' that looks more like a straitjacket, and the once elegant fingers with green nails have turned into paws. HJP

28 *Large Reclining Nude*, 1942
Oil on canvas, 129.5 x 195 cm

Art history – from Giorgione to Rubens, Goya and Renoir – has produced many works to demonstrate that a reclining female nude is among the loveliest and most sensual subjects of all, yet in this picture the reclining figure is devoid of all beauty and eroticism.

Apparently turned to stone, Dora Maar's naked body lies as if thrown down and broken in pieces on a bed, over which the pattern of a spider's web is traced. Her body is incarcerated in a bare, gloomy room like a prison cell in which there is a narrow strip of light, like a gleam of hope, only in the upper edge of the picture.

It is scarcely possible to do justice to the work without taking the cir-

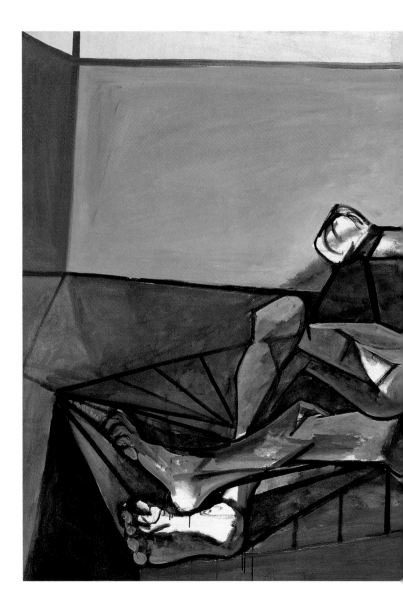

cumstances of its genesis into account. Picasso painted it in 1942 in Paris, which was occupied by the German army at the time. Both he and Dora, who was still his mistress then, suffered psychologically from the confined working and living conditions (among other things, Picasso was not allowed to exhibit), and felt personally threatened. In answer to a question from an American journalist after the liberation whether he had also painted the war, Picasso said no, but added: 'I have no doubt that the war appears in my pictures'. This reclining female nude is thus not just a symbol of an individual's pain, but represents everyone exposed to and defenceless against a superior power.

HJP

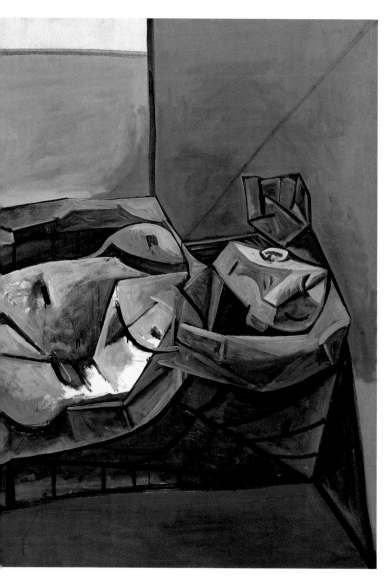

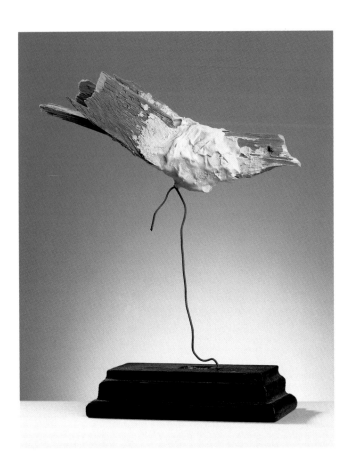

29 *Blackbird*, 1943
Wood, plaster and wire,
18 x 22 x 7 cm (including plinth)

In his sculptures, Picasso frequently made use of everyday utilitarian objects, even when they were worn out or thrown away. Perhaps the best-known work of this kind is the *Bull Skull* of 1942, for which Picasso put the upturned handlebar of a bicycle on a bicycle saddle. This specifically sculptural approach dates back to 1914, when he did his Cubist *Absinthe Glass* (see no. 14).

For the *Blackbird*, he likewise used very ordinary materials. A thin wooden lid, perhaps from a cigar box, was broken lengthways into several pieces, worked up a little with a pointed knife and then tied together with a bandage soaked in plaster, into which a slightly bent wire was also introduced and finally anchored in a cast-off plinth with a classical profile.

Picasso gave the work to Dora Maar, from whom he separated in 1943, when he acquired a new mistress in the younger Françoise Gilot. Perhaps the small, cheerful-looking bird was supposed to comfort her. Or perhaps the blackbird was intended – a few months before the liberation of Paris – as a kind of harbinger of spring. At any rate, Dora Maar kept the *Blackbird* in a showcase in her apartment till the day she died, in July 1997. HJP

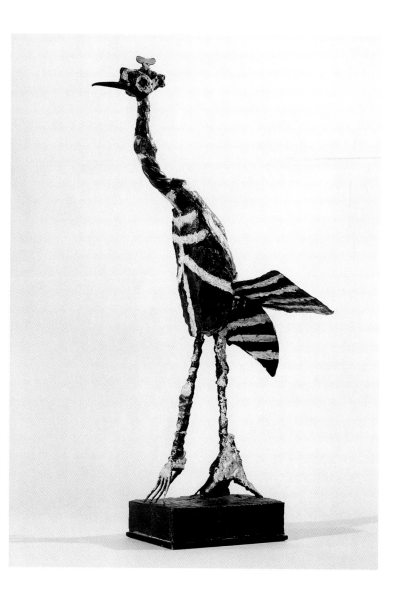

30 *The Crane*, 1951–53
Painted bronze, 74 x 44 x 27 cm

Though, like the *Blackbird*, the *Crane* is composed of found bits and pieces, it was not left that way. Picasso told Françoise Gilot how the idea for this sculpture came to him: 'The material itself – the shape and nature of a [found] object of this kind – often provides the key to the whole sculp- ture. It was the scoop, which remind- ed me of the tail features of a crane, that gave me the idea of doing a crane.' Other found objects were added – a gas tap for the head, a bas- ket frame for the neck, forks for the feet. To unify the discrete materials, he had the *Crane* cast in bronze, but painted each of the four casts with different graphic patterns, so that each is unique. HJP

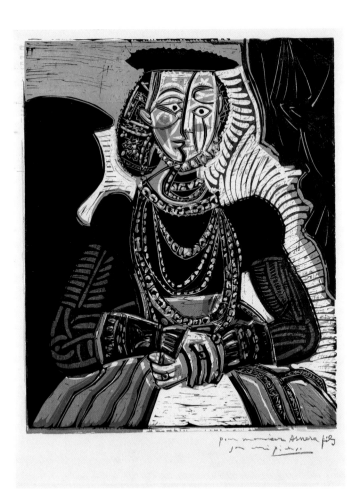

31 *Portrait of a Young Woman after Cranach the Younger (II)*, 1958
Colour linocut, 65 x 53.5 cm

Paraphrasing works of past artists was something Picasso often did, especially in the post-Second World War period. That even a German artist, particularly of the Renaissance period, should awaken his interest, may seem surprising, but from 1949 he returned repeatedly to work from Cranach subjects, among others. When Daniel-Henry Kahnweiler brought back from Vienna a coloured postcard of Cranach's *Portrait of a Young Woman* (1564), Picasso obviously found it appealing enough to do a reworking in linocut, a technique that his printer in Vallauris, Hidalgo Arnéra, had just introduced him to. Though he largely followed his source in the picture, there is a Cubist touch to the face and a mirror-image reversal of the body (the latter for reasons of printing). Indeed, Picasso emphasizes the printing qualities of the linocut: instead of the subtle gradations of a painting, he gives us monochrome areas of colour without any illusion of depth, and overlayering of individual printed colours, discernible in the intentional imprecision of register. As in the work of Edvard Munch, the shadow of the head becomes a threatening alter ego. This was Picasso's first major work in this technique. HJP

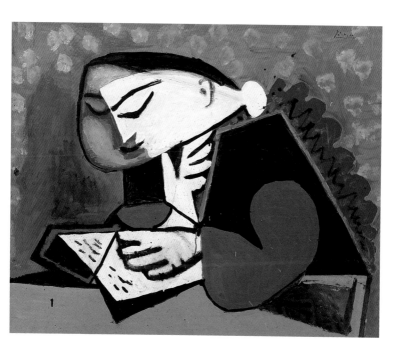

32 *Reading*, 1953
Oil on panel, 81 x 100 cm

Of the many women who shared Picasso's life for long periods, Françoise Gilot was rather special, not least due to her own independence and strength of character. She became Picasso's mistress at 18, and bore him two children, Paloma and Claude. She and her inspired painter spent ten intense years together to their mutual benefit.

It is no accident that we see this intellectual, flexible person in pensive pose, reading. Françoise was many things to Picasso – his muse, mother of his children, critic of his work and an artist in her own right. She was a social asset, and a recognized artist who herself exhibited.

Reading was painted at La Galloise. It is a composition of flat surfaces, each feature – the two sides of the face, black waistcoat, green sleeves, hands, book and table – confined to separate colour areas. Yet a strong three-dimensional, spatial impression remains, created by the shadows under arm and book and the darker side of the double face. The face is shown both frontally (an opulent oval in blue) and in profile (sharply delineated and wan white). The attitude of concentrated reading – the act of cutting oneself off and retreating to an inner world – is hermetic, demarcated against a vividly dotted and smeared background.

Reading was a farewell. On 30 September 1953, Françoise left the great artist – an unforgivable offence – to make a life for herself, both as a mother and as an artist with commissions for book illustrations and theatrical work. Some ten years later, she published *Life with Picasso*, written jointly with art critic Carlton Lake. MK

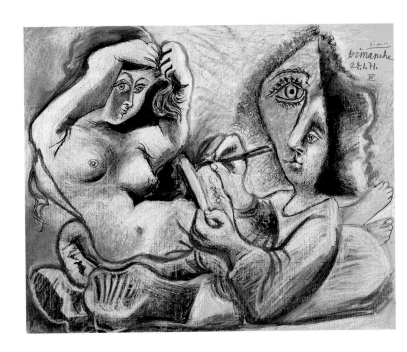

33 *The Painter and his Model*, 1971
Ink, watercolour and pastel on paper,
51.5 x 64.5 cm

When you consider the countless
variations Picasso did on the theme
of artist and model, it is evident that
the subject went to the heart of his
work. An inexhaustible subject, 'artist
and model' became a kind of um-
brella concept for Picasso's passionate
exploration of the possibilities of art
to look at subjects in ever-new ways.
It was a magic potion for genius that
invigorated an ageing body and in-
stilled creative vitality.

This drawing from 24 January
1971 shows a young artist reminis-
cent of Rembrandt, whom Picasso
often harked back to in examining
his own art. The painter is lying on
a mattress, which he shares with his
baroque model. His 'double' face
looks both at the lovely nude and out
of the picture. The over-prominent

eye represents Picasso's interpretation
of real artistic vision (cf. no. 22).

This art of seeing artistically fea-
tures in the picture in various ways.
The thinly applied pastels fill in the
body, clothes and skin of the figures
such that bare patches are left and the
orange background shines through.
The outlines of the bodies are in
contrast quite firm. The drawing pad
and sketching hands of the painter
occupy the centre of the picture,
moving lines of force radiating out-
wards from the hands. It is as if the
gesture of painting and modelling the
body is not only presented to the
viewer's gaze but also comes to life in
the picture itself between the painter
and model. This impression of fer-
vent painting is created by the cur-
sory strokes of red pastel, which
vibrate to and fro mainly between
the 'seeing eye' and the red outline of
the model's arm. MK

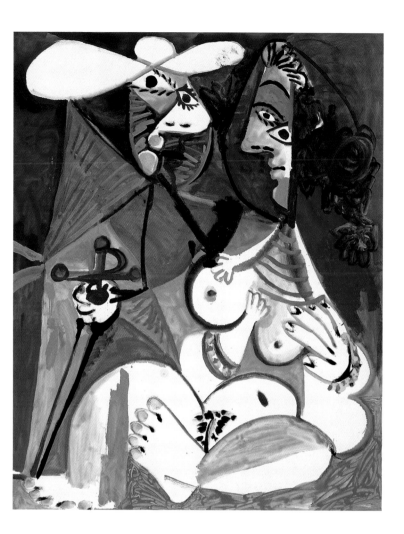

34 *Matador and Nude*, 1970
Oil on canvas, 162 x 130 cm

This picture of a couple belongs to a
bull-fighting series of 1970. Painted
in Mougins when Picasso was 89, it
deals with the subject of art and life, a
sheer inexhaustible source of strength
for the artist. The matador stands rea-
dy for the fray with his blood-red
cloak and drawn rapier.

The painting aims for immediacy
– perhaps a battle of the sexes? Given
Picasso's turbulent life with women,
from whom he drew renewed
strength, this is certainly plausible.
Does the ageing artist create potent

freshness in the twinkling of an eye?
Undoubtedly, because in *Matador
and Nude* the personal motto and its
impression in painting enter into a
symbiosis. The expression of vital im-
provisation predominates.

Spontaneously applied colour
areas, curving lines, deft but rapid
accents (neck jewellery, the matador's
face, the cloak) lend rhythm
to the pictorial event. The opulent
woman's body is left as white ground.
This is an art that highlights the frag-
mentary, a challenge to the viewer
to turn the dot and line of a few basic
details into something wholly dis-
tinctive. MK

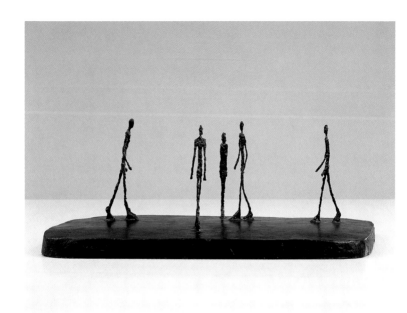

Alberto Giacometti (1901–1966)

35 *Square II*, 1948–49
Bronze, 23 x 63.5 x 43.5 cm

The five attenuated figures with flattened bodies stand only 23 centimetres high on their platform. They were so unspectacularly sized that they, like Giacometti's other elongated sculptures, were almost overlooked at exhibitions. They didn't conform with expected dimensions, and so were considered just as studies.

Giacometti's 'phenomenological' sculptures with their existential vision of humanity do indeed break with popular ideas of sculptural size. Yet the way they express a unique concept of dimension, movement, figure and space is not insignificant. Giacometti shows us what 'appearance' means, and how the spectator's vision adjusts to the object. The idea is of familiar figures striding towards the viewer from afar, almost from the horizon, and this makes the figures shrink and grow sere. Yet they remain identifiable in their characteristic motion. Our experience of reality requires an appropriate distance. The sculptures reconcile our view of things in space and our stored image of them.

In 1961, Giacometti himself said of the four men and one woman in this bronze, which he made after returning to Paris from exile in Geneva, that 'each is apparently pursuing his own way quite alone in a direction unknown to the others. They meet and pass each other by, don't they? … Or else they revolve around a woman.' Is the female figure petrified because four men are approaching her? Or is this a normal scene of unconnected people walking up to each other, meeting and going their own ways – a thing of the moment?

MK

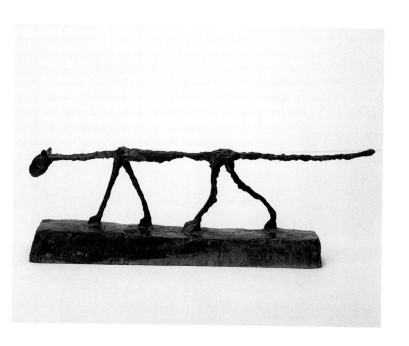

36 *The Cat*, 1951
Bronze, 81 x 25 cm (with base)

This bronze of 1951 is one of only two animal sculptures by Giacometti (the other being *The Dog*, a bronze from the same year).

The 'model' was a cat belonging to his brother Diego, whom he had done a portrait bust of the same year and later worked up into several variants of a head. 'I had seen Diego's cat so often coming across the bedroom to my bed in the morning that I had a very precise idea of it. I just had to make the cat.' As one would expect, it was not a matter of modelling a realistic portrait. As with his people, he sought to render similarity phenomenologically – possibly that very moment of greeting every morning. This is suggested by the stance of the cat, which is walking with head outstretched and tail rising as it nears the familiar person – captured in the moment when head, spine and tail form a straight line. It is physically taut but not psychologically tense – quite different from the posture of an animal about to attack its prey. The cat is not looking for prey; neither is it hiding or escaping. It is attentive, and yet relaxed in its easy gait – the epitome, if you will, of the cat *per se*.

Giacometti's *Dog* is both similar and different. The back sags, the head, tail and floppy ears droop. But both *Cat* and *Dog* remain one-offs within his work. Generally, his figures portray men who apparently move without knee joints and women who stand with their arms pressed close to their sides. MK

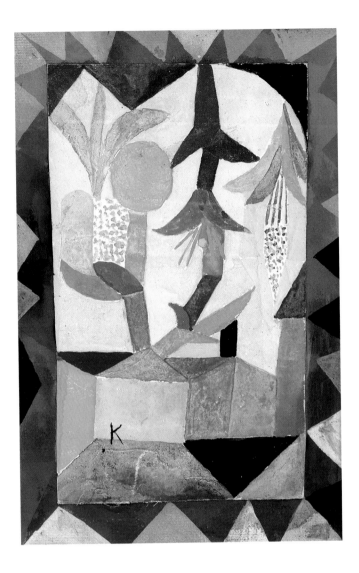

Paul Klee (1879–1940)

37 *Celestial Flowers over the Yellow House (The Chosen House)*, 1917, 74
Watercolour on a chalk ground on canvas mounted on paper laid on card, with water-colour borders, 23 x 15 cm

The numerous triangles in this work form unmarked arrows pointing down to earth and up into the sky. Organic and geometrically rendered natural shapes grow side by side from the roof of the yellow house. Floral growth touches the sky, the frontiers of the earth are breached, the pine tree oscillates in the same rhythm, opened up like an umbrella.

The light, radiant watercolour painting, occasionally broken up by the chalk ground, shows earth resounding in a cosmic dimension. The dark triangles of the 'frame' point to the shadowy realm of un-mined crystals. RM

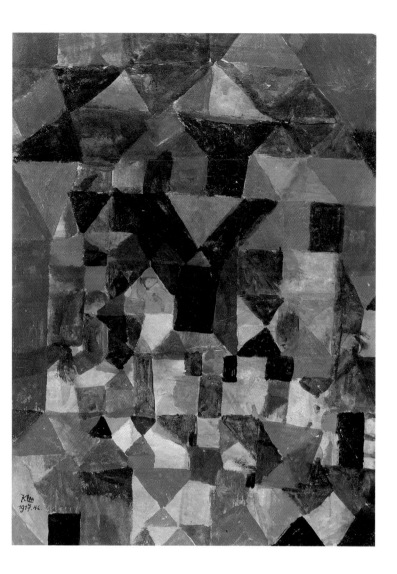

38 *Town-like Construction,*
1917, 46
Watercolour and pencil on card; on the
back, an advertisement for the weekly
magazine *Der Sturm*, 31.5 x 23.3 cm

The centre of this picture is a black
rectangle standing on end, opening
into a 'fork' in the branches. The red
triangle in it suggests a counter
movement downwards. The 'fork'
links the various shapes in an inter-
meshed composition that tilts slightly
to the right.

For all the abstraction, the tri-
angles, squares and rectangles are still
houses, roofs and façades. On the left,
a section of one of them looms quite
massively. It forms a loosely rhythmi-
cized polyphony of smaller and larger
geometrical shapes, carried by the
complementary tones of red and
green, yellow and blue, with an occa-
sional violet in between. This is an
imaginary townscape, radiant in its
colour tones and carpet-like effect –
urban polyphony. RM

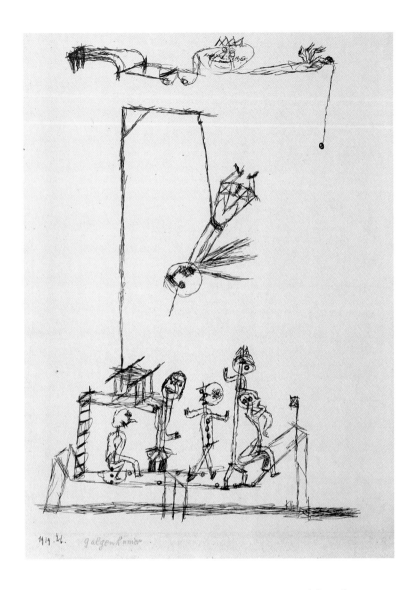

39 *Gallows Humour*, 1919, 26
Ink on paper and card, 28 x 21.5 cm

This drawing is one of Klee's grotesqueries on the last rites for Kaiser Wilhelm II's era.

One of the dangling ghosts hangs head down from the gallows, tied by the waist, its trousers having slipped to tie up the legs, the head a vapid grimace. The gallows themselves are frayed like a rope about to break. Full of mockery, the pantomime community prances around the gallows sneering at its own death. A grinning, crowned something hovers overhead, while a pendulum swings threateningly in the right-hand half of the picture. A slight breeze, and this ghost would collapse in a heap of rubble.

German poet Christian Morgenstern – a kindred spirit – wrote in 1904: 'Gallows poetry is a sort of weltanschauung. Out of it speaks the unscrupulous freedom of the eliminated or dematerialized.' RM

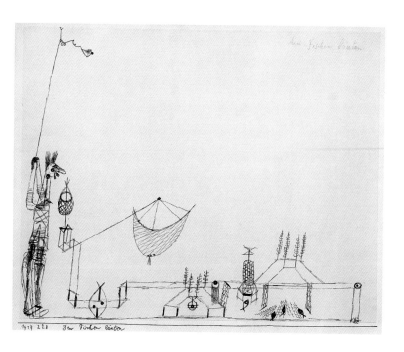

40 *Ringing in the Fish*, 1919, 228
Ink on paper, 22 x 27.9 cm

Feast days and religious services are rung in with loud peals of bells, but what is going on here? The bait above is indeed a little bell that can hardly be heard. No one knows what is going on in the dark depths of the water, in this cold, hermetic world with the smooth, apparently insubstantial magic of the fish. Can fish 'say' anything or even speak? Can they be animated with musical tones and noises? Klee's droll fishing scene is set, of course, on a flimsy stage delineated with thin lines. You have to look hard for the little fish, which dart around in the water of fertility like small arrows or spermatozoa. They are there for a moment, then they're off again. The fishing net and counterweight are constructed tall like technical apparatus and function like that, too, being perfectly balanced.

The wicked angler goes about his devilish game like the Pied Piper of Hamelin. Sooner or later he gets every fish groping into one of his craftily placed traps, two basins with little trees or the fish trap, which looks like a pavilion or a moon probe. Everywhere the finely knotted net is spread out, and the trap will snap shut any moment.

Ringing in the Fish freely translated according to Klee means 'I'll catch you, you slimy, scaly creatures. Now you've had it. And there'll be nothing left of you but the paltry bones of withered trees growing on top of a wall.' A passionate angler and fish-eater, Klee knew all about the pleasures and excitement of fishing, which requires infinite patience. Klee repeatedly captured the elusive, magical world of fish. RM

1920/175 Fliegersturz

41 *Fliers Crashing*, 1920, 175
Oil tracing and watercolour on paper with
dots of glue on card, 31.8 x 24 cm

The bird–plane plunges to earth
against a background of brown spots
verging on light yellow. On its wings
made of squares and rectangles, the
plane is marked with black iron
crosses, the symbol of the Kaiser's
military might, but also a reference to

death that goes with crashing.
In the mechanical structure of the
plane, the eyes and arrow-like feet re-
present organic remnants of the fly-
ing creature 'bird', plunging to
the ground with its sharp beak first. A
few outlines of houses indicate the
aerodrome or a nearby village. The
picture is about the tragic dualism of
rise and fall, heaven and earth, life
and death. RM

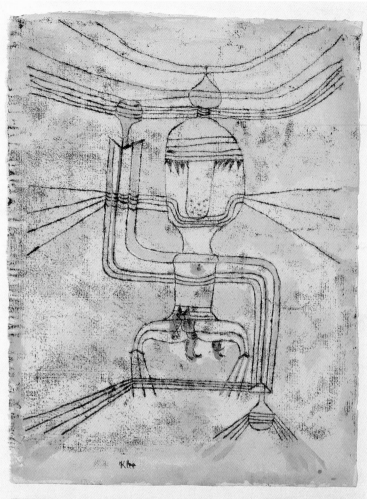

1920 173 Der grosse Kaiser reitet in den Krieg

42 *The Mighty Kaiser Rides to War,*
1920, 173
Oil tracing and watercolour on paper with
dots of glue on card, 31 x 23.8 cm

The war was long over and the Kaiser in exile in Holland when Klee
executed his grandiose satire deconstructing the sovereign, whom he
also called 'Siegfried Meyer' and
'Wilhelm the Great'. In this picture,
the 'Mighty Kaiser' rides to war
through yellow-brown mud. The

balled fists of the 'invincible' emperor
have wasted to little drumsticks,
as Wilhelm II rides blindly, with
closed eyes, over the chasm of heroic
illusion.

Klee depicts the travesty and absurdity of pathos, the craving for
grandeur and the frailty of an
authoritarian feudal system that the
First World War and the November
Revolution of 1918 had brought to
an end. RM

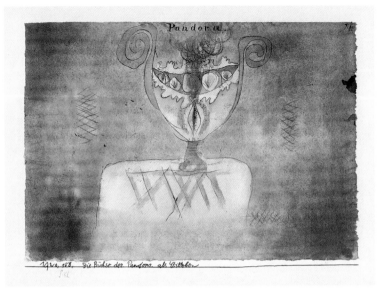

43 *Pandora's Box as a Still Life*, 1920, 158
Oil tracing and watercolour on paper on card, 16.8 x 24.1 cm

'All-gifted' Pandora, endowed with various gifts by the Greek gods and shaped into a seductive woman by Hephaestus, was sent by Zeus as a 'beautiful evil' to punish mankind. Despite Prometheus's warning, his brother Epimetheus took her as his wife. She opened her box (originally a *pithos*) and all the evils flew out, leaving only hope inside.

In 1902, Frank Wedekind had written a tragedy called *Pandora's Box*, and on 6 July 1904 Klee wrote to Lily Stumpf (later his wife): 'Wedekind interests me enormously, more than all the moderns I don't yet know.'

In 1920, Klee initially did a preparatory drawing called *Pandora's Box*. In it, a *pithos*-shaped head sits on the figure's shoulders, while rising vapours enshroud a Biedermeier interior with a piano and covered table. In it are two gnome-like line man-

nequins and two hastily sketched women sitting on chairs.

After this preparatory drawing came the watercolour *Pandora's Box as a Still Life*. To leave no doubt as to the mythological subject matter, Klee wrote the name 'Pandora' at the top. The still life 'swims' on runny burgundy red contrasted with a sharp yellowish green. Now it is just Pandora with the many eyes that predominates, her mouth a vagina and the handle-like ears transformed into a grotesque *pithos*, a head still life pregnant with evil. In Klee's works, Pandora embodies the evil that overtakes the world, but she is at the same time her counterpart, the petrifying gorgon Medusa and the man-eating nymphomaniac. Poisonous perfume flows out of the open vessel, its fatal vapours giving rise to the picture's morbid coloration.

Klee inscribed on his lascivious *Pandora* 'S Kl.' (special category), i.e. a work not to be sold. He kept it in his private collection as an exceptional watercolour to the day he died.

RM

44 *Picture Inscription for Irene, for When She's Bigger (No. 1)*, 1920, 116

Pen and watercolour on paper, with coloured strips of paper added top and bottom on card, 13.5/24.8 x 18.2/32.7 cm

Munich – early summer 1920. The painter Klee and pianist Gottfried Galston (1879–1970) were next-door neighbours living at 32/II Ainmillerstrasse. Galston had come round with his young daughter Florina Irene again, and the adults chatted and made music. At some point, Irene and her beloved godfather, Klee, presumably sat side by side scrawling. The result of this undocumented encounter was the *Picture Inscription for Irene, for When She's Bigger*. A witty little picture with three delightfully fantastic levels of narrative. At the top, the 'elephippopottlefant' snorts noisily while below little trees with spoked wheels go round. A large-headed couple sit side by side in helpless dismay, wondering how they can kiss with pointed noses. Beside them sits Auntie Irene, 'when she's bigger', starchy and severe like a gov-

erness. It was a foretaste of 'life is real, life is earnest', but alas for Irene the grave was its goal all too soon, much to her godfather's sorrow.

Klee used to scrawl his drawings as if into the lines of a notebook or writing pad. A foolhardy boy plunges headfirst from one of the lines into the vacuum, while below a mail coach pulled by a dog clatters off, giddy-up now, we're off to the magic land of childhood dreams. Full and empty parts of the picture alternate, cross-hatching is juxtaposed with rounded shapes. What looks like folded paper drops from the top like a staircase, linking the different levels of narrative. The style is childlike, even infantile, but is handled with the maximum economy of line, and the top and bottom are framed by affixed strips of bluish green paper.

A year later, Klee was already installed in Weimar when the dedication page followed as a present: 'To my god-daughter Irene Galston, August 1921'. The picture was acquired for the Berggruen Collection from the Galston family's estate in 1996.

RM

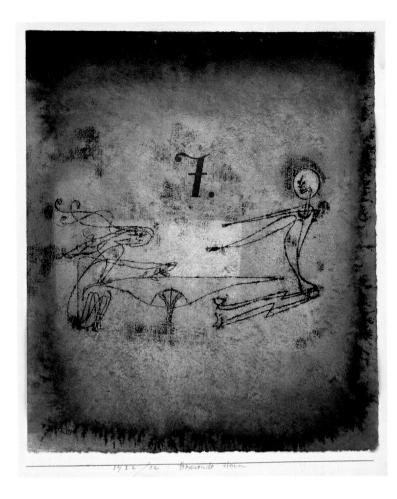

45 *Witches Brewing*, 1922, 12
Oil tracing and watercolour on paper on card, 32 x 27.5/27.8 cm

Taking traditional witchcraft as his starting point, Klee creates a wholly individual style of magic and symbolism. Hence the emphatically positioned 'evil' number '7', which leaves no doubt that something wickedly witchy is going on in the hellishly dirty red-coloured witches' kitchen, charred to ashes at the edges. The dastardly work is being done by two spindly witches pushing and pulling around the firelit tabletop.

After 1933, the conjuring up of good-natured spirits in early Klee witchcraft took on a wholly different, critical dimension in which the Nazi takeover appears in all its menace as the unchained 'militarism of witches'. One year later, the 'degenerate' artist Klee found himself 'jinxed' and 'turned to stone'. This was his own journey to the underworld, where strange, evil, fantastic creatures lived, apparently bewitched for all eternity.

Klee would work out the titles of the pictures, written below on a delicate horizontal line, only after completing them and discussing them with friends. Not infrequently, they have the quality of incantations. RM

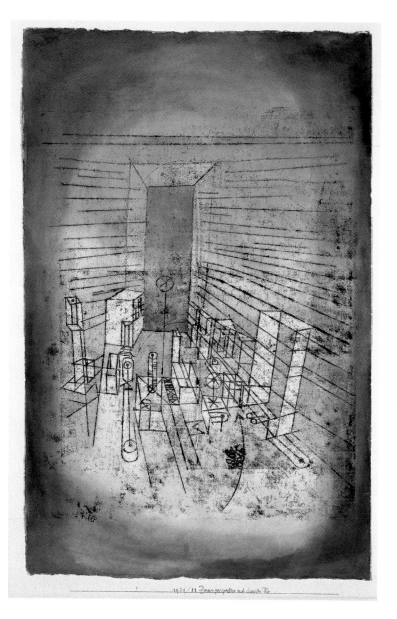

1921/23 Zimmerperspektive mit Einfahrtstür

46 *Perspective of a Room with a Dark Door*, 1921, 23
Oil tracing and watercolour on paper on card, 48 x 31.5 cm

In this painting we see an extremely high, hermetically sealed room, an interior with such furnishings as lamps and indefinable technoid appliances. Klee was not interested here in the harmony and stability evoked by the room but in the temporal dimension of perception in encountering a room with all the factors that create uncertainty (lack of perspective, enclosure, instability, the pull of depth). In this disparate spatial arrangement, the bent arrow is only the spring into a prison of Kafka-esque desolation. RM

47 *Architecture of the Plain*,
1923, 113
Watercolour and pencil on paper on card;
above and below, edge strips with pen and
brush in ink and watercolour,
28/28.2 x 17.2/18.1 cm

Klee drew irregular, slightly curved
lines on the paper with a thin pencil
and without a ruler. In their horizon-
tal and vertical parallelism, they form
the basic framework for an imprecise
overlapping system of squares. Within
a breathing geometric structure, the
sublime colours red, yellow and blue
are graduated from light to dark –

from ultramarine to light azure, from
burgundy to pink and violet, from
light yellow to ochre. Yet the
'conspicuous light' of the visual
'polyphony' (i.e. the interpenetration
of various light/dark or colour
values and transparent light effects)
is not in the middle but below,
where sunshine yellow rises
out of the green plain. For Klee, in
this work the 'architecture of the
plain' is unstable geometrical areas of
colour radiating an inner brightness,
colour veils reminiscent of the later
Colour Field Painting of American
artist Mark Rothko. RM

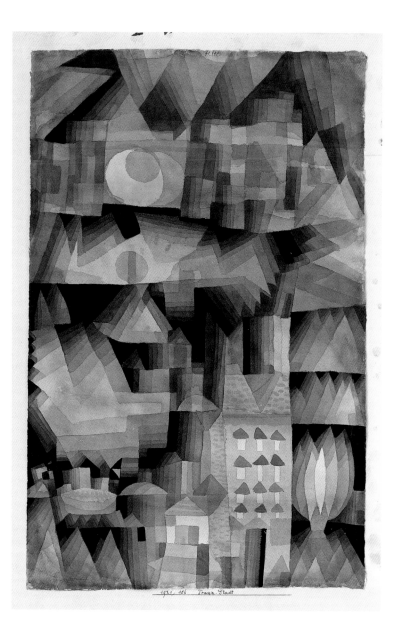

48 *Dream City*, 1921, 106
Watercolour on paper on card, 47.5 x 31 cm

In 1921, Klee followed his fugal,
crystalline step pictures with this
meditative *Dream City* in which
'buildings, too, are conjured up as
crystalline dreams' (Theodor Däub-
ler). The city is a vista of glassy tones

of indigo shading to greenish blue –
houses, roofs, towers accompanied by
buds and mushrooms from the magic
forest. Overhead, bird clouds and tri-
angles sail into the darkness of the
night. The scene shows the enchant-
ment of nocturnal black, a high point
in Klee's crystalline dream con-
figurations. RM

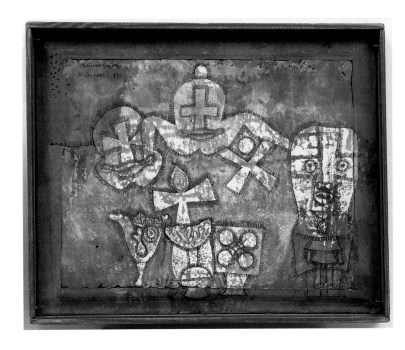

49 *Chinese Porcelain*, 1923, 234
Watercolour on plaster plaque with
wooden frame, 28.6 x 36.8 cm

The first thing that looks Chinese in
this picture is the thick, white, highly
absorbent plaster ground it is painted
on, which is reminiscent of china
clay. Various still-life-like, sketchy
figures emerge from this white base,
shrouded in a diaphanous cloud of
red, yellow and blue watercolours,
which spread on to the frame as well.

It is a strange picture. The head of
the figure bears a Greek cross, which
recurs in the picture. The gnome-like
figure is clutching a doll, its expres-
sion a mixture of drollery and
cruelty. The two balloon-like beings
on the left consist almost entirely of a
cross and big mouth. One has legs as
well. Below are the elements of a still
life, items of everyday use, including a

spout, a vase shaped like a face and a
dice shaker.

Is it supposed to depict a charade
of collector's items escaped from a
showcase, or is it a kind of treasure
trove? Klee loved treasure troves, col-
lections of things that suddenly come
to light after being hidden for hun-
dreds of years. That, too, would be a
possibility. They are not dead objects
looking at us; they are more likely to
be spirits and demons that lived in
the things and shared their fate be-
fore they were put away. They can
take any shape they want, the more
bizarre, the more they frighten
people. A Chinese ghost story, in fact.

Klee's deep old frame creates the
impression of a reliquary, which con-
fers on the collection an enigmatic,
metaphysical quality over and beyond
the merely religious. RM

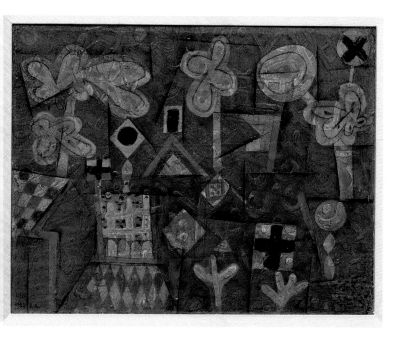

50 *Gingerbread Picture*, 1925, 12 (K2)

Oil and pen-and-ink on chalk ground on card nailed to a stretcher, 21.8 x 28.8 cm

Klee began his picture by applying a chalk-based ground. He then made free use of a spatula, to create motifs in relief to be touched, which is of course incompatible with conservation. Initially, the layering and white plaster hatching was the sum of it, spread out edge to edge. From this, Klee came up with the idea of delicious baked goods, a picture of touchable gingerbread. Heaven forbid anyone should eat the picture, but this pseudo-gingerbread of Christmas bliss is certainly a highly 'appetizing' Klee.

It seems inconceivable, however, that a Klee should use the stock image of gingerbread. No, he invents something new, a synthesis of garden and still life as an earthly force field. The sticky pieces of gingerbread are stacked up beside each other, over-painted brown, to form the delicious, decorated humus with latent powers for the paradise garden Klee builds above it, which includes a gazebo with a diamond pattern and a chess-board carpet, red-spotted fan and trumpet trees ruffled by the wind. Interspersed throughout the composition are various cruciform traffic signals.

Klee's spellbound gardens of mystery are completely independent of the caprices of the season, for they come back to life even when nature has withered and died in the cold of winter, when the gingerbread dispenses inner warmth and content-ment. In typical Klee fashion, the title is neatly written underneath to form a kind of 'poetic gloss over the pic-ture' (Werner Haftmann). RM

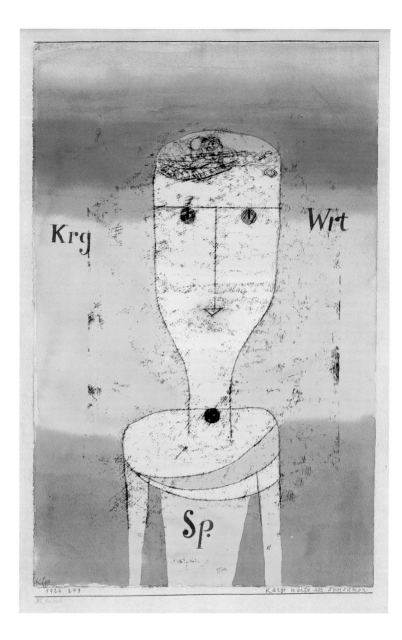

51 *Spr Wrds f th Tctrn Mn,*
1924, 249

Watercolours and oil tracing on paper on
card, 44.8 x 29.3 cm

Depicted here is a cursorily sketched
figure with two button eyes, a straight
line for a nose and a tiny triangle of a
mouth. It is a pinched, shuttered,

sealed face. In the ochre areas, Klee
has written, in abbreviated form, the
words of the title very prominently
in a triangular arrangement: Krg
(karg = spare), Wrt (Worte = words),
Sp (Sparsamen = the taciturn). On
the crown of the head is a tangle of
unsorted thoughts. RM

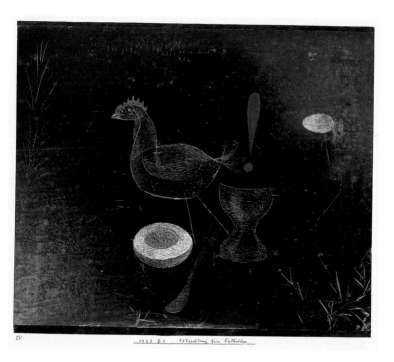

IV

1925 8.3. Betrachtung beim Frühstück

52 *Contemplation at Breakfast,*
1925, 113 (B3)
Watercolour and gouache on paper on card;
above and below, margin strips done with
a pen, 23.5 x 28.2 cm

Contemplation at Breakfast on a Sunday morning: what came first, the chicken or the egg? The red exclamation mark gives a categorical answer to the question – the next egg goes into the empty eggcup. That is the fate of the ungainly chicken with the flaming red comb and star eyes. In front on the table is the open egg with the hard shell, inner skin, yoke and egg white, and the spoon alongside. On the grey-blue-black slate, motifs are traced sharply in thin, opaque watercolour, magic signatures for the egg, incised and cross-hatched for all eternity. The philosophical egg looks coldly out of the mysterious darkness, rather like Brancusi's *Sculpture for the Blind* of 1916. The black magician Klee saw the egg right

from the first as the 'point of creation', the primeval cell for the birth and resurrection of life, but over and above this as a symbol of the act of creation in his art.

With this picture, Klee rolls the egg of alchemy out into the chicken run. The hen is clucking there, but where is the cock crowing? An answer might be found in the German Romantic poet Clemens Brentano's tale entitled the *Gockel, Hinkel und Gackeleia* (The Cock, the Pullet and the Clucking; 1838): 'Solomon, o wise king, to whom the spirits are subject, / Fill the chicken coop forthwith! Let all the brightly coloured hens / Cluck, scratch, brood, hatch, protect you from the lofty cock! / Let him watch over them all, go up and down proudly with spurs, / Hold high his comb and tail, valiantly flap his wings / Crow like a court herald, so that each may say on seeing him / Wholly with truth: There indeed goes a chevalier.' RM

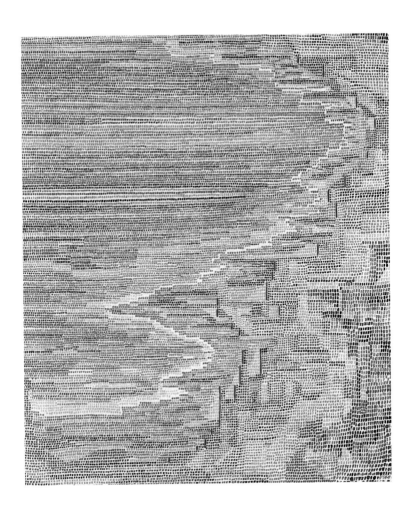

53 *Classic Coast*, 1931, 285 (Y5)
Oil on canvas on a stretcher, 80.5 x 68 cm

1931 was the year of Klee's Pointilliste Period. How important this style was to him is evident from the fact that he abandoned the floating indefiniteness of watercolours for this technique and worked on the canvas with the clarity of oil colours.

The points are not round here but irregularly square or rectangular, alternating from brittle brown to yellow, green and blue. They are placed on the canvas with anything but casual abandon. A floating mid-grey impression predominates in which Klee has organized a subtly nuanced 'battle' between pure black and pure white.

Klee's pointilliste coast is a classically balanced rectangle clearly divided into two halves, one characterized by emptiness, the other by fullness. The image is rendered as though seen by a bird in flight, viewed from below in the elevation and from above in the ground plan, carried out in a systematic counterpoint of individual broken lines and a 'dividual' structure of rhythmicized sequences of coloured dots. RM

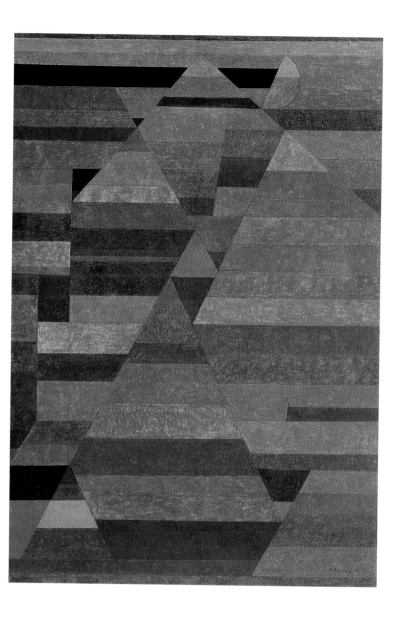

54 *Necropolis*, 1929, 91 (S1)
Oil on nettlecloth and plywood, 63 x 44 cm

At the turn of 1928/29, Klee travelled to Egypt. Visiting the pyramids in Giza and staying in Luxor and Aswan had a long-term effect on the artist's style. This was less a matter of the mythology in stone of these places than his fascination with the symbolically triangular pyramids, which

subsequently prompted Klee, once back in Dessau, to embark on a series of watercolours and pictures of the utmost structural rigour. In this picture, the pyramids are rhythmically built up in stripes of differing widths in a transcendental array – a visual geometry of tapestry-like beauty, conjured up out of the darkness of human history. RM

55 *Doorway of a Mosque,*
1931, 161 (S1)
Pen and watercolour on paper on card,
37.5/43 x 29/33 cm

A plunge into the glistening world of
mosaic stones – the mosque doorway
is framed left and right in tiny square
shades of blue that evoke the world
beyond. Irregular points of red thrust
forward. In the middle there is the
suggestion of a balcony or balustrade
verging on green, while the blue
fades into the turquoise at the back.

The verticals in yellow hint at a
courtyard in the sunlight. The for-
wards and backwards, the analogous
and contrapuntal rhythmicization of
coloured mosaic stones creates the
impression of overlapping interiors.
In its light-filled, polyphonic musica-
lity, this picture surpasses the pointil-
lisme of Klee's works around 1930. It
represents the artist's 'work in the top
circle' – time stops, enclosed with
light in the complex abstraction of
the picture. The rest is mystery.

RM

56 *Time*, 1933, 281 (Z1)

Watercolour and brush and ink on a plaster ground of multiply overlaid pieces of gauze on plywood; on the back, watercolour on plaster ground, 25.5 x 21.5 cm

In December 1933, now branded a 'degenerate' artist, Klee left Germany and settled in Berne, Switzerland, where his father and sister lived. 'I've been kicked out', he commented.

Klee's commentary on time was done in 1933, using unusual materials. Taking some gauze, he prepared a piece of plywood with plaster and stuck three rectangular pieces of gauze on top of each other in diagonally staggered positions. He over-painted his 'collage' with predominantly red waxed watercolours that range from sgraffito yellow to faded red and sandy brown. The stuck-on materials are porous and threadbare, i.e. time has already left its traces as a destructive factor. Time stands still, and the clock hands point only to an uncertain, gloomy future. The picture is an admonitory icon and unstable transit station on the way to disasters not yet known. RM

57 *Cityscape of Knossos*, 1940,
294 (K14)
Watercolour and paste paint on paper
on card, 29.3 x 41 cm

Yellow and red watercolours were
applied thinly to the paper in broad
strokes, leaving a light blue area at the
top evoking the light-filled atmos-
phere of the Mediterranean. Imposed
on this in the heavy black of paste
paint is the freehand outline façade
of a massive palace like a dark grille
of inaccessibility. A dotted street with
archetypal passers-by appears in front
of it. The façade occupies the whole
width of the picture, with an un-
adorned door in the middle whose
thick black line symbolizes the way
into the world of the past. On the
left, bathed in bright light, is a
narrow, tower-like feature with a
separate entrance and an idol-like
face framed in a rectangle.

Klee never went to Greece, but he
knew about the myth of the ancient
Cretan settlement with its extensive

palace complex dating from the
20th–16th centuries BC. Daedalus
built the multi-storey building of
Knossos grouped around a central
courtyard for the legendary Cretan
king Minos, who kept the Minotaur
captive there. The complexity of the
layout resembled a maze from which
there was no escape. Only Theseus
found the way out of the labyrinth
with the help of Ariadne's thread.

Aware of the imminence of death,
Klee was working harder than ever.
This picture dates from March 1940,
and in its intellectual quintessence
reflects an almost palpable notion of
the labyrinthine, the hopelessness of
escape in a last, light-filled surging
moment of vitality that is soon dis-
pelled in darkness. In his lively
arrangement of symbols, Klee varied
between objectivity and abstraction.
This picture belongs incontestably to
the first category, though concrete
and abstract visual elements are com-
bined here. RM

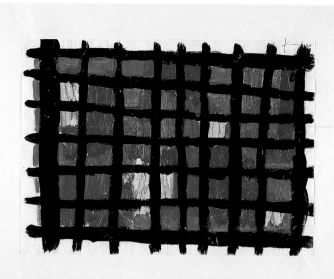

1940 b 15 der Teppich

58 *The Carpet*, 1940, 275 (L15)
Paste paint on paper with spots of glue on card, border strip on the card below in ink, 29.5 x 41.7 cm

The nearer death came after a long, severe illness, the more powerful became Klee's intuition and the 'minimalism' of this archaic, sign/picture style. For him, *The Carpet* of 1940 was already imbued with the threatening presence of death. A grille with black bars is drawn with a bushy brush in paint as black as night horizontally and vertically in irregular brushstrokes over the yellowed, rough paper. The lines are frayed at the ends, and open in every direction. The hieroglyph of the grille weighs heavily. Under it gleams a weave of red and blue, brown and light green applied in broad strokes of paste paints.

It is the brightness of colours from the depths, apparently held in place by lead cames like in stained-glass windows, but without the bright promise of divine redemption. In Klee's *Carpet* the shutter of death has come down on the beauty of the world. The grille serves as a reminder that there is no escaping mortality. Deeply immersed in his predicament, completely himself and totally aware of the fullness of life, Klee the artist was yet aware of the inevitability of extinction and the void.

With his death in spring 1940, Klee's dream of art as a metaphor of creation had come to an end, incomplete: 'Sometimes I dream a work of enormous range, spanning the whole elemental terrain of things, content and style. ... It must grow, it should burgeon ...'

His visual legacy of over 8,000 works keeps the 'genesis' as realized, spiritual movement with all its wealth of inventive imagination alive for eternity – 'art is like a parable of creation.' RM

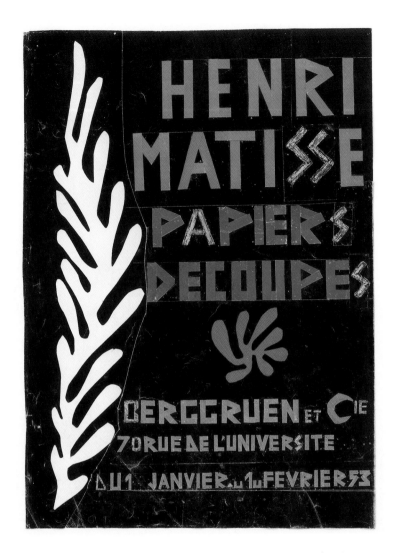

Henri Matisse (1869–1954)

59 Rough for an exhibition poster
for the Galerie Berggruen, Paris, 1952
Gouache cutouts on card, 55 x 40.3 cm

Two years before he died, Matisse did
a poster for the first exhibition of his
late *papiers découpées*. This rough for it
features two floral shapes on a black
ground in a composition containing
angular letters. Not all the letters are
in place yet. Not surprisingly, this
draft never went to print. In the ver-
sions used, the dominant plant shape

and a more conventional script are
more clearly separated. But the vari-
ous corrections he made offer in-
sight into Matisse's working methods
and his handling of typography. The
pictures selected in the studio were
shown at the gallery in the Rue de
l'Université in 1953 – it was the gal-
lery's third exhibition, and the first
showing anywhere of the late gouache
cutouts. DS

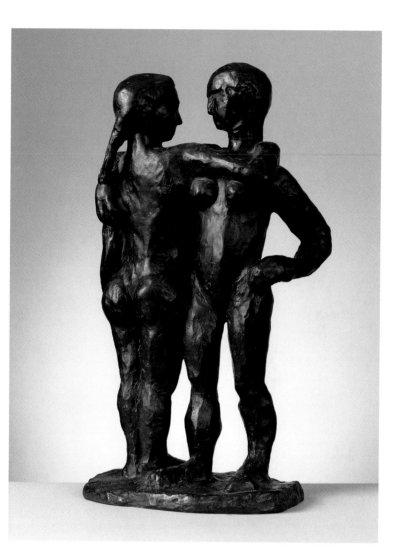

60 *Two Young Women*, 1907/08
Bronze, 46.5 x 25.8 x 18.3 cm

'When I got tired of painting, I did
sculpture.' That sculpture was more
than a release from painting is evi-
dent from this bronze of two women
– a double image that seems to be
more of a reflection. It is known that
from 1904 Matisse based some of his
works on photographs that appeared
in *Mes Modèles* magazine. In this case
it was an image of two Tuareg women,
as the original French title *Deux
Négresses* hints.

The harmony, physique, immobil-
ity and poses of the figures were un-
doubtedly transposed from the
original photograph. The specific
features of the faces, hands and hair
were not adopted, but were simpli-
fied into the stocky, earthbound
character of the overall composition.
It was the architecture of the human
body that appealed to the artist – the
body as a 'building' in which each
individual part has a particular role.
Moreover, this bronze is early
evidence of the influence primitive
sculpture exerted on Matisse. MK

61 *In the Studio in Nice*, 1929
Oil on canvas, 46.5 x 61 cm

Matisse spent over half his life in Nice. When he installed himself in the Beau Rivage hotel at the end of 1917, he was 48 years old. Nice represented inspiration, bright, gleaming light and all the splendid colour of the Côte d'Azur.

The present picture shows the studio in the flat in Place Charles-Félix, with an extensive fourth-floor view of the open sea. Three factors govern the composition, which picks up the theme of interior and exterior: the recurrent motif of the window frame; light-filled colours that span different objects; and the establishment of an ambivalent art-space.

The view into and out of the studio is composed in a way that makes the walls look like opened shutters. The large floor-length windows do not constitute a barrier here, creating two separate worlds. Interior and exterior worlds blend to form a pastel-coloured, light-flooded whole. In Matisse's own words, 'I can join together the chair that stands beside me in the studio, the cloud in the sky and the palms rustling on the shore', not least because 'the atmosphere of the landscape and the interior form a unity.'

Matisse bathes the studio in a fluid, milky light. The predominately pastel colour harmonies extend beyond the confines of individual objects (ceiling, window frames, tiles, carpet, curtain etc.). Though the accessories of the room – the chair with the cushion, the large mirror, the small table with the torso on it – remain visible, the strength of the painting does not rely on the opulence of the richly furnished room. Matisse has kept the scene fluid, beginning with the length of transparent material in front of the figure seated at the desk. The element water enters the interior as the bright turquoise of the table top. The sun outside shines as a bright yellow curtain inside. The blue of the sky suggests the linear ceiling decoration. The greenish black of the palm tree becomes a drawn imitation of the wall tiles. MK

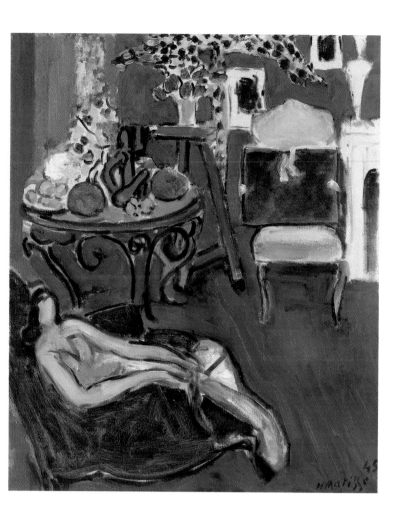

62 *The Blue Portfolio*, 1945
Oil on canvas, 55.3 x 46.7 cm

This studio scene of 1945 contrasts completely with the painting of the studio in Nice. No light floods the picture. Red predominates, on floor, walls, curtain – a red mixed with black, applied in restless brushstrokes, making the room almost palpable and creating spatial effects. Matisse paints in protest against war, his illness and the suffering of his family. (In 1944, his wife, Amélie, and daughter, Marguerite, had been arrested for their links with the Résistance.)

The Blue Portfolio is thus a kind of artistic double take, a collection of objects and motifs that had in the meantime become famous. The pink Rococo chair 'presents' the closed portfolio to the viewer. It keeps concealed what we can see – melons, a bronze and a seated nude on the table. In the left foreground, a dancer reclines like an odalesque in a rocaille chair. Matisse's poet-friend Louis Aragon had spoken of a 'vocabulary of things' – the artist's passion for living in the middle of all the objects that communicate with each other in his paintings. MK

63 *Head of a Woman*, 1951
Ink on paper, 42.5 x 33 cm

'The human face has always interested me very much. … Every figure has its special rhythm, and it's this rhythm that creates similarity', said Matisse. A notable example of this rhythm is the *Head of a Woman*.

Matisse captured the specific character of the face with the very simple means of line. Only eleven continuous strokes of the brush model the woman's face. The lines vary in strength – there is a deliberate contrast between the calm, firm brushstroke of the lower line of the face with chin and cheeks (and the drawing of brows, eyes, nose and mouth) and the upper half of the head with hairline and wavy hairstyle. The seemingly smudged line describes here what the hair is like in reality – fine hair that is sometimes unruly.

From the 1930s, Matisse was constantly striving to economize with painterly resources by using line drawing. It was succinct, expressive and very precise.

In 1908, he said that he was striving for an 'art of balance and purity' that 'neither calms nor confuses. I should like tired, overburdened humanity to find peace and calm in my pictures.' In view of the *Head of a Woman* and the painter's bad state of health, this seems almost like a recipe for his own recovery. In 1949, Matisse had retired once more to the former Hotel Régina in the hills of Chimiez. In the bedroom studio near Nice, which he painted from his sickbed, the walls were covered with a frieze of ink drawings of various faces.

MK

64 *The Filled Stillness of the Houses*,
1947
Ink on paper, 61.5 x 48.5 cm

After the bombing of Nice, Matisse
moved into Le Rêve, a villa on the
edge of Vence, which is where this
picture was drawn – the title was
taken from the first line of a poem by
Aragon.

Around 1947, Matisse returned to
the subject matter of interiors. This
drawing was done at the same time
as a painting of the same name, and
shows clear parallels with two others
in the Barnes Collection depicting
two girls on a red background and

against a blue garden. Both there and
here, Matisse makes use of the win-
dow motif, with two women sitting
at a table reading.

Three-quarters of the picture is
taken up by the open window with a
view into the garden. The differen-
tiated shading and nuances in the ap-
plication of ink 'open up' pictorial
and spatial planes. The staffage, in-
terior and exterior combine to form
a pattern that covers the entire pictor-
ial surface. The leaves sticking out of
the vase towards the garden link the
head of the woman on the right with
the bushes in the background, and
create the impression of depth. MK

65 *Vegetable Elements*, 1947
Gouache découpé on paper on linen,
65 x 50 cm

'To my eyes, the cut-outs, which border on the abstract, have something magical. … Their formal idiom is profoundly poetic and at the same time monumental. I can imagine someone living in a huge white house lit up just by a cut-out by Matisse.' (Heinz Berggruen)

 In fact, this might apply to the benign colour impact of the intense vegetable shapes of different sizes against a bright red background. Simplification is the essence of this gouache découpée, meaning a reduction to essentials, opening up a range of associations with organic elements, such as coral, exotic foliage and trees of life.

 Despite the disapproval of well-known dealers and critics, in 1953 Heinz Berggruen ventured to put on an exhibition devoted solely to the *papiers découpés*, so convinced was he of their artistic force. The exhibition was a great success. MK

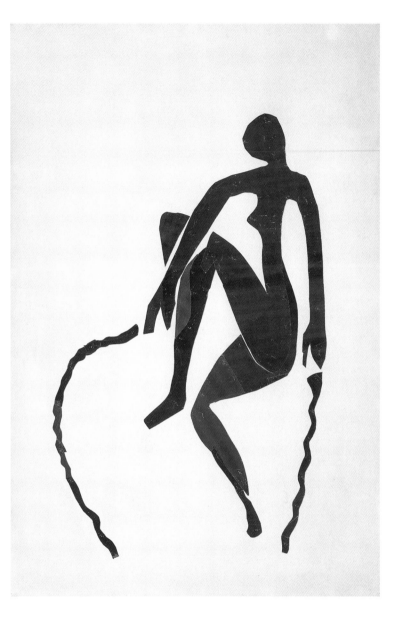

66 *Woman Skipping*, 1952
Gouache découpé in blue on paper,
145 x 98 cm

Reduction to essentials means in this cut-out the act of motion. Matisse had already explored this in 1909, then in the early 1930s with the *La Danse* wall pictures and the first cutouts. In the late work, the tendency towards minimalized visual symbols became ever more pronounced. Now, after the design of the chapel in Vence and the frame-filling *Blue Nudes*, arabesques and interlacings predominate. Here this translates into a free-floating body created by arranging and affixing curvaceous, undulating pieces of blue paper to a paper ground. MK

Artists' Biographies

GEORGES BRAQUE

was born in 1882 in Argenteuil-sur-Seine. From 1897 to 1899 he attended evening classes at the art school in Le Havre, and in 1899 began training as a painter and decorator there, subsequently continuing in Paris. At the end of 1902, he gave up decorating entirely in favour of art, and studied at the Académie Humbert and the Ecole des Beaux-Arts until 1904. Impressed by the paintings of the Fauves, he began to do pictures in the same style, but soon abandoned the attempt following the Cézanne retrospective in 1907, which had a profound effect on him. The same year he made Pablo Picasso's acquaintance, and was strongly influenced by *Les Demoiselles d'Avignon*, which Picasso had just finished. The paintings he produced the following year, which the Salon d'Automne rejected but dealer Daniel-Henry Kahnweiler exhibited in his new gallery (Braque's first solo show), were characterized by a critic as 'cubes'. 1909 can be identified as the real beginning of Analytical Cubism. The growing friendship with Picasso from that date, which resulted in joint summer working holidays, confirmed the similar orientation of their art and led to the birth of Synthetic Cubism in 1912. In the First World War, Braque was severely wounded in the head, but after being demobilized returned to painting. At the 1922 Salon d'Automne, the Salle d'Honneur was reserved for Braque's work. In 1931, he spent the summer on the coast of Normandy, and in 1933 had his first major retrospective, at the Kunsthalle in Basle. In 1937, he was awarded the Carnegie Prize in Pittsburgh. During the German occupation of France he remained mainly in the Pyrenees, returning to Paris only in 1944. In 1945, he had to undergo a serious operation. In the two decades after the war many honours were conferred on him, including the Grand Prix of the Venice Biennale in 1948, and a number of special exhibitions were devoted to his work both in the United States and Europe, such as a retrospective at the Tate Gallery in London. He died in Paris in 1963.

ALBERTO GIACOMETTI

was born in 1901 in the Swiss mining village of Borgonovo near Stampa (in the canton of Graubünden), the son of a distinguished painter. He enrolled as a student at the Ecole des Beaux-Arts and the Ecole des Arts et Métiers in Geneva in 1919, where several months of study in Italy formed part of the course. In 1922, he went to Paris, and for five years he attended – if somewhat irregularly – sculpture classes given by Antoine Bourdelle at the Académie de la Grande Chaumière. In 1927, he moved into the small studio in the rue Hippolyte-Maindron, where he would live with his slightly younger brother, Diego, to the end of his days. His first Surrealist sculptures date from the late 1920s. In 1932, he had his first solo exhibition, organized by the Galerie Pierre Colle in Paris. In the mid-1930s, he broke away from the Surrealists. Although he had in the meantime gained international recognition, he still needed to earn a living, and with Diego he produced craft objects, such as furniture and lamps, for home furnishings company Jean-Michel Frank. His preoccupation in the decade to 1945 was a search for a new way to present the relationship between figures and space. He made friends with Pablo

Picasso and Jean-Paul Sartre. After the Germans occupied Paris, Giacometti went back to Geneva, in 1942. In October 1943, he became acquainted with Annette Arm (1923–1993), later his wife, who often served as his model. On his return to Paris in 1945, his new style came together at last. His first postwar solo exhibition was organized in 1948 by the Pierre Matisse Gallery in New York. 1950 was the year of his first retrospective, in Basle, and the museum there was the first to buy works of his for a public collection.

Henceforth, solo and group exhibitions in Europe and America would follow in great number. He first took part in the Venice Biennale in 1956, in the French section, whereas the second time (1962) he won the state prize for sculpture. Further honours followed in the 1960s: the Grand Prix for sculpture of the Carnegie Foundation in Pittsburgh (1961), the New York Guggenheim Prize for painting (1964) and an honorary doctorate from the University of Berne (1965). Giacometti died in Chur at the beginning of 1966.

PAUL KLEE

was born in Münchenbuchsee near Berne, Switzerland, in 1879. He studied in Munich from 1898 to 1901, initially at a private art school, then, from 1900, under Franz Stuck at the Academy of Fine Arts. After a six-month spell in Italy (1901/02), he returned to Berne, where he did a series of grotesque etchings. In September 1906 he married Munich-born pianist Lily Stumpf, and in early October moved to Munich. The Kunstmuseum in Berne organized his first solo exhibition, which subsequently toured Zurich, Winterthur and Basle. In 1911, he became acquainted with Wassily Kandinsky, August Macke, Franz Marc and other members of the Blaue Reiter group, and took part in their second exhibition a year later. At the end of 1913, he was one of the founders of the New Munich Secession. The following year, he and Macke went to Tunis together. From 1916 to 1918, he served in the German army. In early 1919, he was a member of committees of the Bavarian 'Räterepublik'; when it collapsed, he fled to Switzerland. In October 1920, he was appointed to the staff of the Bauhaus in Weimar, where he published an

essay called 'Schöpferische Konfession' (reprinted as 'Creative Credo' in *The Notebooks of Paul Klee*, vol. 1, pp. 76–80), then, in 1924, gave his lecture 'Vom Vorbildlichen zum Urbildlichen' at the Kunstverein in Jena. In 1925, he moved with the Bauhaus to Dessau, publishing in that year extracts from his lectures in *Pädagogisches Skizzenbuch* (translated as *Pedagogical Sketchbook*, New York, 1953). At the end of the year, he took part in the first group exhibition of the Surrealists, at the Galerie Pierre in Paris. In 1931, he gave up his teaching post at the Bauhaus in Dessau to take up an appointment at the Academy in Düsseldorf. In 1933, he was dismissed by the Nazis, and by the end of the year Klee had left Germany for Switzerland, where, in 1935, the Kunsthalle in Berne put on a retrospective of 273 works. In 1937, over 100 of his works were removed from public collections in Germany during the Nazis' Degenerate Art campaign. That year, Klee met Picasso in Berne. In 1935, progressive scleroderma had struck him, and in June 1940 he died in Muralto, Locarno.

HENRI LAURENS

is represented in the Berggruen Collection by a bronze of 1932 entitled *Small Pregnancy*. Born in Paris in 1885, he went to the Ecole Bernard Palissy before entering the studio of a decorative sculptor (1899), where he modelled architectural ornaments and did architectural drawings. After that, he worked as a stonemason, attending art classes in the evenings. From 1905 to around 1911, he shook off academicism, but also rejected Auguste Rodin's criteria as a guide for the sculptor, seeking a voice of his own in synthetic sculpture. In 1911, he met Georges Braque, with whom he formed a lifelong friendship and through whom he also became acquainted with Pablo Picasso, Fernand Léger, Juan Gris and the literati associated with Guillaume Apollinaire. Braque introduced Laurens to Cubism, and the latter developed a style of his own from it. The first surviving sculpture, *Portrait of Marthe Gireud*, dates from 1912. That year also saw his first experiments with Cubism, mostly in painted clay. 1913 brought

his first participation in the Salon des Indépendants. His first surviving Cubist works (paper collages, small wooden figures) date from 1915. Through Picasso, Laurens made the acquaintance of dealer Léonce Rosenberg, who organized the sculptor's first exhibition in 1917. From the mid-1920s, Laurens gradually abandoned his strictly Cubist style and turned to organic, figurative sculpture. Around 1932/33, he embarked on a phase of dynamic, voluminous works, of which *Small Pregnacy* is a good example. He had several works on show at the World Fair in Paris in 1937. In 1948, Laurens was France's representative sculptor at the Biennale in Venice. In 1950, Henri Matisse pointedly shared his Biennale prize with Laurens, and singled him out as a major inspiration. His most comprehensive retrospective to date was held at the Musée National d'Art Moderne in Paris in 1951. Laurens died in Paris in 1954.

HENRI MATISSE

was born in Le Cateau-Cambrésis, Picardy, in northern France in 1869. He initially studied law in Paris, and after gaining his diploma worked for a law firm, beginning painting only in 1890. After studying briefly at the Académie Julian in Paris, in 1892 he was admitted to Gustave Moreau's studio at the Ecole des Beaux-Arts there. In 1898, he married Amélie Parayre. His first sculpture, which would lead to a major group of works, dates from 1900. In 1904, he had his first solo show, at Ambroise Vollard, and the following year exhibited at the Salon d'Automne, where he featured as the leader of the new Fauves group. In 1906, he travelled to Algeria, subsequently buying an African mask. In April of that year,

he met Pablo Picasso at the home of Gertrude and Leo Stein. His first lithographs and woodcuts followed. From 1908/09, his international reputation grew as a consequence of solo exhibitions, e.g. in New York, Moscow and Berlin (though at the latter exhibition his work was not well received). In 1911, he travelled to St Petersburg and Moscow at the invitation of his collector Sergei Shchukin. From 1922, his previous sporadic visits became regular six-month spells in Nice, followed by six months in Paris. In 1924, the Ny Carlsberg Glyptotek organized the most comprehensive exhibition of his work to date. A stay in Tahiti in 1930 proved a memorable experience. The same year, the Galerie Thann-

hauser in Berlin showed 265 of his works, and this was followed by retrospectives in Paris, Basle and New York. At the outbreak of war in September 1939, Matisse left Paris. In 1941, he underwent two major operations for duodenal cancer, as a consequence of which he was later largely bedridden. In these difficult circumstances, he turned increasingly to the technique of *papier découpés*, which enabled him to remain artistically active. In 1943/44, he worked mostly on the *Jazz* album to be published by Tériade. In 1944, his wife and daughter Marguerite were arrested for their part in the Résistance. After the liberation, Matisse returned to Paris in summer 1945 and henceforth lived there, alternating between Vence and Nice. In 1947, he was made a commander of the Légion d'honneur. In the post-war decade, his work consisted almost entirely of *papiers découpés*, including wall-sized decorations, such as *Oceania the Sky*, *Oceania the Sea* (1946) and *The Parrot and the Mermaid* (1952). A major commission carried out from 1947 to 1951 was the interior and external furnishing of the Chapel of the Rosary at Vence, which he likewise designed with paper cut-outs. In 1950, he represented France at the Biennale in Venice, winning first prize. The Galerie Berggruen in Paris put on the first-ever exhibition of his paper cut-outs, in March 1953. Matisse died in Nice in 1954.

PABLO PICASSO

was born in Málaga, Spain, in October 1881. His extraordinary artistic gift was recognized and encouraged by his father, a drawing master, from an early age. In 1895, he went to art school in Barcelona, where he became associated with the avant-garde artists who frequented the Els Quatre Gats cabaret restaurant. In autumn 1897, he enrolled at the academy in Madrid, but broke off his studies in the middle of the following year because of illness. To recuperate, he went to Horta de Ebro. He returned to Barcelona in 1899, moving into a studio of his own. In autumn 1900, he spent some weeks in Paris for the first time, and for the next four years alternated between Barcelona and Paris, painting the pictures of his Blue Period. In 1904, he moved to a studio in the Bateau-Lavoir artists' colony, where the following winter he met his first great love, Fernande Olivier. Picasso soon became the centre of a group known as the *bande à Picasso*, which included poets Max Jacob and Guillaume Apollinaire. He also made the acquaintance of Leo and Gertrude Stein and art dealer Daniel-Henry Kahnweiler. 1905 marked the beginning of Picasso's Rose Period. In 1906, he met Henri Matisse, and a year later Georges Braque and André Derain. In 1907, he completed *Les Demoiselles d'Avignon*, the first pre-Cubist masterpiece. In the next few years, partly as a result of his collaboration with Braque, Derain and others, his style passed through Analytical Cubism (1909), Synthetic Cubism (1912) and, from 1914, a modified form of Cubism alongside the first Neoclassical drawings. Involvement with Sergei Diaghilev's Ballets Russes (costumes and sets) led to a trip to Rome in 1917, where he met the Russian ballerina Olga Khoklova, whom he married in 1918 (a son, Paolo, was born in 1921). In the first half of the 1920s, he did monumental paintings and large-format pastels in a Neoclassical style. In 1925, he took part in his first Surrealist exhibition, at the Galerie Pierre in Paris. In 1935, a former friend from his Barcelona days, Jaime Sabartés, became his secretary, and a liaison with Marie-Thérèse Walter (dating back to 1927)

produced a daughter, Maya. The same year he produced a major graphic work, the *Minotauromachia*. From around this time, his partner was photographer Dora Maar. In 1936, the Republican government in Spain appointed him director of the Prado in Madrid, and a year later commissioned the *Guernica* mural for the Spanish Pavilion at the Paris World Fair. In 1939, the Museum of Modern Art in New York organized a major retrospective of his work. During the German occupation of France, he remained mostly in Paris, where he was forbidden to exhibit. After the liberation of Paris in August 1944, he had 74 pictures and five sculptures on show at the Salon d'Automne. Around this time, he became a member of the Communist Party. Early in 1944, he had met the painter Françoise Gilot, who for the following decade became his partner and mother of their children, Claude (1947) and Paloma (1949). He took part in world peace conferences in Poland (1948), England (1950) and Italy (1951). In 1949, he moved to the south of France, where, in Vallauris, he had already been experimenting intensively with the techniques of ceramics since 1947.

In 1954, Jacqueline Roque became his partner after Françoise left him, and in 1958 he married her. That year he also did a mural for the UNESCO headquarters in Paris. During the two post-war decades, he did extensive series of prints.

In 1970, a Picasso museum was set up in Barcelona, which contains donations from the artist himself (particularly early works done in Barcelona) and the estate of Jaime Sabartés, who died in 1968. The Louvre put on a special exhibition in honour of his 90th birthday. Picasso died in Mougins in April 1973. The Musée Picasso in Paris, containing many works from his estate, was opened in 1985.

SELECTED BIBLIOGRAPHY

GENERAL LITERATURE

Albrecht, Thomas. 'Das Picasso-Museum: Zur Umgestaltung des westlichen Stüler-Baues'. *MuseumsJournal* 10, no. III (July 1996): 19–21.

Berggruen, Heinz. *Highways and Byways*. Intro. Neil MacGregor. London, 1998. Originally published as *Hauptweg und Nebenwege: Erinnerungen eines Kunstsammlers*. Berlin, 1996 (7th ed. 2001).

——. *Abendstunden in Demokratie*. Berlin, 1998.

——. *Ein Berliner kehrt heim: Elf Reden (1996–1999)*. Berlin, 2000 (expanded ed. 2002).

——. *Monsieur Picasso und Herr Schaften*. Berlin, 2001.

——. *Spielverderber, nicht alle*. Berlin, 2003.

Berggruen, Oliver (ed.). *Van Gogh to Picasso: The Berggruen Collection at the National Gallery*. Supplement. London, 1994.

Cramer, Patrick. *Hommage à Heinz Berggruen: Liste des Expositions à la Galerie Berggruen*. Geneva, 1988.

Einstein, Carl. *Die Kunst des 20. Jahrhunderts*. Berlin, 1926.

Hildebrandt, Hans. *Die Kunst des 19. und 20. Jahrhunderts*. Potsdam-Wildpark, 1924.

Kendall, Richard (ed.). *Van Gogh to Picasso: The Berggruen Collection at the National Gallery*. Texts by Lizzie Barker and Camilla Cazalet. London, 1991.

Knopp, Werner (ed.). 'Deutschland dankt Ihnen: Ansprachen zur Eröffnung der Sammlung Berggruen – Picasso und seine Zeit', *Jahrbuch Preussischer Kulturbesitz*, vol. XXXIII/1996. Berlin, 1997, pp. 37–62 (speeches by Eckart Werthebach, Roman Herzog, Eberhard Diepgen, Heinz Berggruen).

Lehmann, Klaus-Dieter (ed.). 'Ansprachen zur Vertrags-Unterzeichnung der Übereignung der Sammlung Berggruen', *Jahrbuch Preussischer Kulturbesitz*, vol. XXXVII/2000. Berlin, 2001, pp. 43–50 (speeches by Gerhard Schröder, Eberhard Diepgen, Heinz Berggruen).

[MD]. 'Picasso und seine Zeit: Die Sammlung Berggruen: Der bedeutendste Kunsttransfer der Nachkriegszeit'. *MuseumsJournal* 9, no. III (July 1995): 75.

Papies, Hans Jürgen. '"Kunstsammeln ist wie eine Droge": Neuerwerbungen für die Sammlung Berggruen.' *MuseumsJournal* 12, no. II (April 1998): 33–35.

——. 'Ständig wachsend: Die Sammlung Berggruen'. *Jahrbuch Preussischer Kulturbesitz*, vol. XXXVI/1999. Ed. Klaus-Dieter Lehmann. Berlin, 2000, pp. 249–64.

——. 'Picasso und seine Zeit: Sammlung Berggruen'. In *Schätze der Weltkulturen in den Sammlungen der Stiftung Preussischer Kulturbesitz*. Ed. Klaus-Dieter Lehmann. Berlin, 2000, pp. 71–78 (amended English version 2001).

——. 'Sammlung Berggruen: Picasso und seine Zeit'. In *Die Nationalgalerie*. Ed. by Peter-Klaus Schuster. Cologne, 2001, pp. 76–81, 248–73, 316–17.

——(ed.). 'Picasso und seine Zeit: Die Sammlung Berggruen'. *Bestandskatalog* (inventory) (4th expanded ed.). Berlin, 2003.

Pury, Simon de (ed.). *Collection Berggruen*. Musée d'art et d'histoire, Geneva, 1988. Geneva and Milan, 1988.

Schneider, Angela, and Roland März. 'Picasso und seine Zeit: Die Sammlung Berggruen'. *MuseumsJournal* 10, no. III (July 1996): 22–27.

Schuster, Peter-Klaus. 'Heinz Berggruen oder die Kunst des Sammelns'. *MuseumsJournal* 10, no. III (July 1996): 16–18 (the updated version is contained in the 4th expanded edition of the inventory published in 2003, 'Picasso und seine Zeit: Die Sammlung Berggruen').

Struck, Gabriele. *Sammlung Berggruen: Museumsführer für Kinder*. Ed. Waldtraut Braun. Berlin, 1999 (2nd expanded ed. 2001).

GEORGES BRAQUE

Isarlov, Georges. *Catalogue des œuvres de Georges Braque 1906–1929*. Paris, 1932.

Leymarie, Jean (ed.). *Braque*. Geneva, 1961; Munich, 1988.

Ponge, Francis, Pierre Descargues and André Malraux. *G. Braque*. Trans. R. Howard. New York, 1971.

Pouillon, Nadine, and Isabelle Monod. *Œuvres de Georges Braques (1882–1963):*

Catalogue des collections du Musée National d'Art Moderne. Paris, 1982.

Russell, John. *Georges Braque*. London, 1959.

Worms de Romilly, Nicole, and Jean Laude. *Braque: Le Cubisme fin 1907–1914*. Paris, 1982.

Zurcher, Bernard. *Georges Braque: Leben und Werk*. Munich, 1988.

ALBERTO GIACOMETTI

Beye, Peter, Reinhold Hohl and Dieter Honisch (eds.). *Alberto Giacometti*. Berlin and Munich, 1987.

Bucarelli, Palma. *Alberto Giacometti*. Rome, 1962.

Dupin, Jacques. *Alberto Giacometti*. Paris, 1962.

Genet, Jean. *Alberto Giacometti*. Zurich, 1962.

Hohl, Reinhold. *Alberto Giacometti*. Stuttgart, 1971.

——(ed.). *Giacometti: Eine Bildbiographie*. Ost-fildern-Ruit, 1998.

Klemm, Christian, Carolyn Lanchner, Tobia Bezzola and Anne Umland (eds.). *Alberto Giacometti*. Zurich and Berlin, 2001.

Lamarche-Vadel, Bernard. *Alberto Giacometti*. Paris, 1984.

Lord, James. *Alberto Giacometti: A Biography*. New York, 1985.

Scheidegger, Ernst (ed.). *Alberto Giacometti: Schriften, Fotos, Zeichnungen*. Zurich, 1958.

Schneider, Angela (ed.). *Alberto Giacometti: Sculptures, Paintings, Drawings*. Trans. Eliza-beth Clegg. Munich and New York, 1994.

Stooss, Toni, Patrick Elliott and Christoph Doswald (eds.). *Alberto Giacometti, 1901–1966*. Ostfildern-Ruit, 1996.

PAUL KLEE

Bischoff, Ulrich. *Paul Klee*. Munich, 1992.

Fath, Manfred (ed.). *Paul Klee: Die Zeit der Reife*. Munich and New York, 1996.

Geelhaar, Christian. *Paul Klee: Life and Work*. Woodbury, New York, London and Toronto, 1982. Originally published as *Paul Klee: Leben und Werk*, Cologne, 1974.

Gerlach-Laxner, Uta, and Frank Günter Zehnder (eds.). *Paul Klee im Rheinland: Zeichnungen, Aquarelle, Gouachen*. Cologne and Bonn, 2003.

Grohmann, Will. *Paul Klee*. Trans. Norbert Guterman. London, 1967. Originally published as *Der Maler Paul Klee*, Cologne, 1966.

Haftmann, Werner. *The Mind and Work of Paul Klee*. New York, 1954.

Klee, Paul. *Pedagogical Sketchbook*. Intro. and trans. Sibyl Moholy-Nagy. New York, 1953; repr. London, 1984. Originally published as *Pädagogisches Skizzenbuch*.

——. *The Diaries of Paul Klee, 1898–1918*. Ed. and introduced by Felix Klee. Berkeley and Los Angeles, 1964; London, 1964.

——. *Schriften: Rezensionen und Aufsätze*. Ed. Christian Geelhaar. Cologne, 1976.

——. *Catalogue raisonné*, published by Paul Klee-Stiftung, Kunstmuseum, Berne. Vols. 1–6 (1883–1933). Berne, 1998–2002 (vols. 7–8 forthcoming).

Kort, Pamela (ed.). *Paul Klee: In der Maske des Mythos*. Cologne and Munich, 1999.

Lang, Lothar (ed.). *Paul Klee: Die Zwitscher-maschine und andere Grotesken*. Berlin, 1981.

Papies, Hans Jürgen. 'Überraschende Begeg-nungen mit Klee'. *MuseumsJournal* 12, no. III (July 1998): 76–79.

Paul-Klee-Stiftung, Kunstmuseum, Berne, and The Museum of Modern Art, New York. *Paul Klee: His Life and Work*. Ost-fildern-Ruit, 2001.

Regel, Günter (ed.). *Paul Klee Kunst-Lehre: Aufsätze, Vorträge, Rezensionen und Beiträge zur bildnerischen Formlehre*. Leipzig, 1987.

Rewald, Sabine. *Paul Klee: The Berggruen Klee Collection in The Metropolitan Museum of Art*. New York, 1988.

Spiller, Jürg (ed.). *The Notebooks of Paul Klee*. Vol. I: *The Thinking Eye*. Trans. Ralph Man-heim with Charlotte Weidler and Joyce Witterborn. Vol. II: *The Nature of Nature*. Trans. Heinz Norden. London, 1961. Originally published as *Paul Klee: Das bild-nerische Denken*, Basle, 1956.

Werckmeister, Otto Karl. *Versuche über Paul Klee*. Frankfurt, 1981.

Zahn, Leopold. *Paul Klee: Leben, Werk, Geist*. Potsdam, 1920.

HENRI LAURENS

Hofmann, Werner. *The Sculpture of Henri Laurens*. New York, 1970.

Laurens, Marthe. *Henri Laurens: Sculpteur*. Paris, 1955.

HENRI MATISSE

Abrams, Harry S. *Matisse*. New York, 1972.

Alpatow, Michael W. *Henri Matisse*. Moscow, 1969.

Aragon, Louis. *Henri Matisse: A Novel by Aragon*. Trans. Jean Stewart. 2 vols. London, 1972. Originally published as *Henri Matisse: Roman*, Paris, 1971.

Berggruen, Olivier, and Max Hollein (eds.). *Henri Matisse: Drawings with Scissors: Masterpieces from the Late Years*. Trans. Paul Aston. Munich, Berlin, London and New York and Schirn Kunsthalle Frankfurt, 2002. Originally published as *Henri Matisse: Mit der Schere zeichnen: Meisterwerke der letzten Jahre*, Munich, Berlin, London and New York and Schirn Kunsthalle Frankfurt, 2002.

Cowart, Jack, Jack D. Flam, Dominique Fourcade and John Hallmark Neff. *Henri Matisse: Paper Cut-Outs*. Detroit, 1977.

Delectorskaja, Lydia. *Henri Matisse: Peintures de 1935–1939*. Paris, 1986.

Diehl, Gaston. *Henri Matisse*. New York, 1958. Originally published in Paris, 1954.

Duthuit, Claude (ed.). *Henri Matisse: Catalogue raisonné de l'œuvre sculpté établi avec la collaboration de Wanda de Guébriant*. Paris, 1997.

Elderfield, John. *The Drawings of Henri Matisse*. London, 1984.

Elsen, Albert Edward. *The Sculpture of Henri Matisse*. New York, 1972.

Flam, Jack D. (ed.). *Matisse on Art*. London, 1973.

——. *Matisse: The Man and His Art, 1869–1918*. London, 1986.

Gauss, Ulrike. *Henri Matisse: Zeichnungen und Gouaches découpées*. Ostfildern-Ruit, 1993.

Gowing, Lawrence. *Matisse*. London, 1979.

Güse, Ernst-Gerhard (ed.). *Henri Matisse: Drawings and Sculptures*. Munich, 1991.

Matisse, Henri. *Jazz*. With contributions by Egbert Baque and Katrin Wiethege. Munich, London and New York, 2001.

Néret, Gilles. *Matisse*. London, 1993.

Papies, Hans Jürgen: '"Mit der Schere zeichnen": Henri Matisse im Hause Berggruen', *MuseumsJournal* 16, no. II (April 2003): 66–68.

Schneider, Pierre. *Matisse*. London, 1984.

PABLO PICASSO

Baer, Brigitte. *Picasso Peintre-graveur* (sequel to catalogues by Bernhard Geiser). 3 vols. Berne, 1986–89.

——. *Picasso: The Engraver – Selections from the Musée Picasso, Paris*. London, 1997.

Baldassari, Anne. *Picasso Photographe, 1901–1916*. Paris, 1994.

Barr, Alfred Hamilton. *Picasso: Fifty Years of his Art*. New York, 1946.

Brosthaus, Karl-Heinz. *Die Plastik 'Le verre d'absinthe' von Pablo Picasso im Kontext der kubistischen Skulptur*. Münster, 1997.

Caws, Mary Ann. *Dora Maar, with and without Picasso: A Biography*. London. 2000. The German edition, *Dora Maar: Die Künstlerin an Picassos Seite*, Berlin, 2000, includes a foreword by Heinz Berggruen.

Cooper, Douglas, and Gary Tinterow. *The Essential Cubism, 1907–1920: Braque, Picasso and their Friends*. London, 1983.

Daix, Pierre. *La Vie de peintre de Pablo Picasso*. Paris, 1977.

——. *Dictionnaire Picasso*. Paris, 1995.

Eluard, Paul. *A Pablo Picasso*. Geneva, 1944.

Geelhaar, Christian. *Picasso: Wegbereiter und Förderer seines Aufstiegs 1899–1939*. Zurich, 1993.

Gilot, Françoise, and Carlton Lake. *Life with Picasso*. New York, 1964.

Goeppert, Sébastien, and Herma C. Goeppert-Franck. *La Minotauromachie de Pablo Picasso*. Geneva, 1987.

Kahnweiler, Daniel-Henry. *The Rise of Cubism*. Trans. Henry Aronson. New York, 1949. Originally published as *Der Weg zum Kubismus*, Munich, 1920.

——. *The Sculptures of Picasso*. Trans. A. D. B. Sylvester. London, 1949. Originally published as *Les Sculptures de Picasso: Photographies de Brassaï*, Paris 1948–49.

Lord, James. *Picasso & Dora: A Memoir*. London, 1997.

Mailer, Norman. *Picasso as a Young Man*. New York, 1995.

Olivier, Fernande. *Picasso and his Friends*. Trans. Jane Miller. New York, 1965. Originally published as *Picasso et ses amis*, Paris, 1933.

Palau i Fabre, Josep. *Picasso: Life and Work of the Early Years, 1881–1907*. Oxford, 1981.

——. *Picasso Cubism, 1907–1917*. Trans. Susan Branyas, Richard-Lewis Rees and Patrick Zabalbeascoa. New York, 1990.

——. *Picasso: From the Ballets to Drama, 1917–1926.* Trans. Richard-Lewis Rees. Cologne, 1999.

Papies, Hans Jürgen. 'Picasso in Berlin'. Part I: to 1945. *MuseumsJournal* 10, no. III (July 1996): 28–32. Part II: 1945 to today, *MuseumsJournal* 10, no. IV (October 1996): 21–25. Reprint of both parts in special edition of *MuseumsJournal* (July 1997): 14–23.

Parmelin, Hélène. *Picasso Says.* Trans. Christine Trollope. London, 1969. Originally published as *Picasso dit …*, Paris, 1966.

Penrose, Roland. *Picasso: His Life and Work.* 3rd ed. Berkeley and Los Angeles, 1981 (1st ed. London, 1958).

Raynal, Maurice. 'Les papiers collés de Picasso'. *Arts et Métiers Graphiques*, no. 46 (15 April 1935).

Richardson, John. *A Life of Picasso, 1881 to 1906.* In collaboration with Marylin McCully. London, 1991.

——. *A Life of Picasso, 1907–1917: The Painter of Modern Life.* In collaboration with Marilyn McCully. London, 1996.

Rubin, William (ed.). *Picasso in the Collection of The Museum of Modern Art.* New York, 1972.

——(ed.). *Picasso and Portraiture: Representation and Transformation.* London, 1996.

Sabartés, Jaime. *Picasso: Un portrait intime.* Paris, 1946.

——. *Dans l'atelier de Picasso.* Paris, 1957.

Schmidt, Diether (ed.). *Pablo Picasso.* Berlin, 1970.

Schürer, Oskar. *Pablo Picasso.* Berlin and Leipzig, 1927.

Seckel-Klein, Hélène. *Picasso Collectionneur.* Paris, 1998.

Spies, Werner. *Picasso: Pastelle, Zeichnungen, Aquarelle.* Stuttgart, 1986.

——. *Kontinent Picasso: Ausgewählte Aufsätze aus zwei Jahrhunderten.* Munich, 1988.

——. *Picasso's World of Children.* Munich and New York, 1994.

Spies, Werner, and Christine Piot. *Picasso Sculpture: With a Complete Catalogue.* Trans. John Maxwell Brownjohn. London, 1972. Originally published as *Pablo Picasso: Das plastische Werk: Werkverzeichnis der Skulpturen in Zusammenarbeit mit Christine Piot.* Stuttgart, 1983 (2nd rev. ed. of 1971 book *Pablo Picasso: Das plastische Werk*).

——. *The Sculptures.* Ostfildern-Ruit, 2000.

Stein, Gertude. *Picasso.* Boston, 1959. Originally published in Paris, 1938.

Tzara, Tristan. *Picasso et les chemins de la connaissance.* Geneva, 1948.

Ullmann, Ludwig. *Picasso und der Krieg.* Bielefeld, 1993.

Warncke, Carsten-Peter, and Ingo F. Walther. *Pablo Picasso, 1881–1973.* 2 vols. Cologne, 1992.

Weisner, Ulrich. *Picasso.* Bielefeld, 1997.

Zervos, Christian, *Pablo Picasso: Catalogue des peintures et dessins.* 33 vols. Paris, 1932–78.

AFRICAN ART

Anderson, Martha G. *Central Ijo Art: Shrines and Spirit Images* (Ph.D. diss.). Bloomington, Indiana, 1983.

Bascom, William R. *African Art in Cultural Perspective.* New York and London, 1973.

Dapper, Olfert. *Africa, being an accurate description of the regions of Ægypt, Barbary, Lybia …* London, 1670.

Duchâteau, Armand. *Benin: Royal Art of Africa from the Museum für Völkerkunde,* Vienna. Munich and New York, 1993.

Eisenhofer, Stefan, Iris Hahner-Herzog and Christine Stelzig. *Mein Afrika: Die Sammlung Fritz Koenig.* Munich, London and New York, 2000.

Förster, Till. *Die Kunst der Senufo.* Zurich, 1988.